TRENDS

2009/10 from Central Saint Martins

TRENDS

2009/10

from Central Saint Martins

Edited by Kevin Tallon

BATSFORD

First published in the United Kingdom in 2008 by
Batsford
10 Southcombe Street
London W14 0RA

An imprint of Anova Books Company Ltd

ISBN: 978 19063 8822 5

A CIP catalogue record for this book is available from the
British Library.

16 15 14 13 12 10 09 08
10 9 8 7 6 5 4 3 2 1

Reproduction by Rival Colour Ltd, UK
Printed by SNP Leefung Ltd, China

This book can be ordered direct from the publisher at the website
www.anovabooks.com or try your local bookshop

Front Cover
Central Saint Martins
Graduate Fashion show May 2008
Alithia Spuri-Zampetti, BA Fashion Womenswear
Photography: Neus Rodriguez

Back Cover
Michael Costello
Collateral Damage

Cover Design: Saints Team

Contents

00.

Introduction

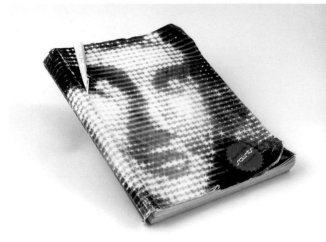

Early mock-up of Saints Trends book (2003)

The Origins

Good things comes to those who wait…so goes the proverb, but how long does one need to wait to get something good? Sometimes the wait is so long that no one even remembers when it really started. As far as waiting for Saints Trends to become a published book, it has been more than seven years. From high hopes to highly detailed plan of action for guaranteed success, everything under the sun has been tried and tested during this long journey.

While studying at Central Saint Martins, I was always encouraged to be creative through lateral thinking, exploration, and crossing over disciplinary boundaries and subjects taught within the college. Fashion students hung out with the fine art crowd, graphic designers collaborated with product designers. Unique inter-disciplinary creativity and cross-pollination was common inside the college. This unique mindset certainly influenced me in shaping and developing the Saints Trends of today.

In its original inception, Saints was meant to showcase the best students coming out of the world-famous Central Saint Martins College of Art and Design. Soon after, an element of trend forecast set in, probably encouraged by my fashion background. The content was still unclear, the format vague, but an all-encompassing drive to produce a book representing Central Saint Martins' creative spirit set in a trend context

kept the project alive. Meanwhile, Saints evolved into a consultancy business within the Central Saint Martins Design Laboratory. Innovative companies such as Nokia and the Gucci Group started to request trend- and creative intelligence-based consultancy. They understood that the pioneering creativity of today's youth would influence the masses tomorrow. Because of its privileged position within the world-famous art and design college, Saints had a unique selling point: it bridged the gap between pure creativity and business realities.

As the consultancy grew in confidence and experience, time was found to revisit the idea of the Saints Trends book. In 2006 a poster/DVD format trend forecast was developed in-house and used as a marketing tool to promote both our services and trends based on Saint Martins graduates. The response was overwhelmingly positive and enabled me, amongst other things, to pitch the concept to Anova Books and get the project underway.

New blood, raw trends

Fascination with youth is not a new phenomenon but it is one that has evolved and grown in influence. Whereas previously youth was defined to a short timespan in anyone's life, today it can run from blogging nine-year-old 'tweenies' to forty-something 'kidults' still stuck on their XBox. Everybody wants to and can define themselves as young for longer. Marketers have long recognised the disproportionate influence youth

Saints Trends DVD (2005)

Saints Trends Poster and DVD (2007)

holds and are ready to spend untold amounts of cash scrutinizing youth in all its forms and manifestations. What young people do, think, consume, and how they communicate is collated, analysed and translated for all kinds of campaigns, products and strategies. But more often than not, marketers are biased and do not truly understand what today's youth are really about. Marketers can be an uneasy bridge between youth as a source of inspiration and the client they serve. They often need to 'interpret' youth in a way most suitable to a specific product or campaign.

Taking this into consideration, the Saints team is made up of a constantly evolving cohort of graduates initially selected from Central Saint Martins but recently broadening to the University of the Arts London's various colleges. Today's graduates will permeate the creative industries in years to come, gradually working their way up the professional ladder with their aesthetic predelictions. The key concept of youth and early-adoptive-based trends has been nurtured overtime at Saints. Developing new methodologies to gather creative intelligence and how to represent it has been a constant challenge. Conscious that the world does not revolve around a London-based college, Saints Creative Intelligence constantly researches and connects with the outside world, linking relevant global trends. This book contains work from graduates based in other international colleges, reflecting our connections with the outside world.

Saints Trends 09/10

Trends 2009/10 is the annual editorial of what I and my team believe are the most important design and sociocultural trends coming out of Central Saint Martins and the University of the Arts London, representing in a clear and concise manner early trend directions. Amongst the maelstrom of creativity, we have edited, sourced and narrated key early trends, mixing and matching creative disciplines, acknowledging that everything influences everything. From a considerable amount of design data, we have thin-sliced the most influential, directional and creative work in its rawest and earliest form with enough imbedded flexibility to adapt over a 12 to 24 months forecast.

The book contains ten key trends, every one of which has various proportions of design and art discipline. For this edition, a fair amount of strong and influential work comes from the Fine Art and Product/Industrial Design courses, work that has caught our attention because it is not formulaic but fresh and vibrant. This book is meant to inspire, challenge, enthuse and envision what trend directions will be key in 2009 and 2010.

Kevin Tallon
Trends Editor

01.

Corrupted Creation

Global corporations are becoming very good at fulfilling our expectations, at creating demand where there is none, at designing desirable, almost fetishistic products at a frenetic rate with which ultra-fast obsolescence is the aim. Consumers are sleepwalking into buying the latest mobile phone, computer and plasma TV even if their current gadgets are alive and well. Manufacturers are enamoured with their own creations, their brand image and status; they proactively avoid any interaction with their customers and access to the inner workings of their wares in a drive to push sales up and promote consumption.

The days when anyone could fiddle around with their cassette player and mend rather than spend are long gone. Companies have become so scared that things might go wrong when interaction is concerned that even instruction manuals need their own instructions. If there is any interaction, it comes as the odd removable fascia. On the other hand, in the name of profit, manufacturers are quite happy to impose strict control on compatible formats, accessories and networks that phones and consoles run on.

Responding to this current climate, 'Corrupted Creation' is an assertive trend with anarchic characteristics. Users, designers and artists rebel against the intangible interfaces of high-tech appliances as they get their hands dirty by getting stuck in, hacking away at the latest technology. Gadgets are customized to the point of being sodomized, wheelchairs are transformed into diggers and goldfish are used as guinea pigs when testing out the vibrations of hi-fi speakers under water. Mundane, everyday objects are turned into 'art-creating' machines and sewing machines into beat-stitching ghetto blasters. Experimentation and lateral thinking are key ingredients; surprise and awe are expected.

Whether it's the hardcore techies who relish the challenge of hacking into the software of their new iPhones or users seeking to develop a meaningful interaction process, this pro-active approach sees consumers taking control, embarking on experimental, user-friendly escapades and challenging the 'complete package' mentality. Users are also seeking to humanize their technology, performing 'circuit bending' in order to better understand it. Children's toys are taken apart and rewired to produce warped and glitchy sounds either to discover uncharted musical territory or just to see what happens when circuit boards are rewired. They want to feel included, and claim true ownership of the digital gadgets that increasingly define who they are.

In a time when the latest gadgets are measured in desirability by how many features they have, the modern world is awash with over-complicated, multi-functioning electronics. Consumers, especially the elderly and the poor, are being left behind by the fast pace of modern digital life and are either forced to accept a complete package or be isolated in a kind of digital no-man's-land. Companies able to re-engage and open up to people's natural curiosity and taste for discovery are likely to enjoy better customer satisfaction and interest, from early adopters to latecomers.

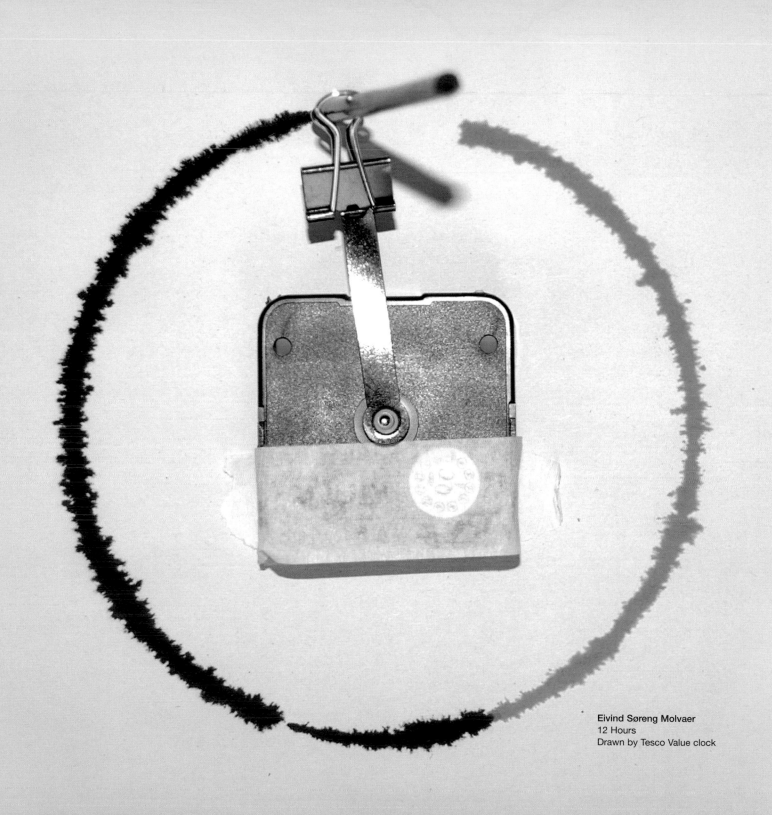

Eivind Søreng Molvaer
12 Hours
Drawn by Tesco Value clock

Matt Bucknall
Creative Environments, Disruptive
Spaces & Places of Influence
Disruptions, Reminders &
Interventions

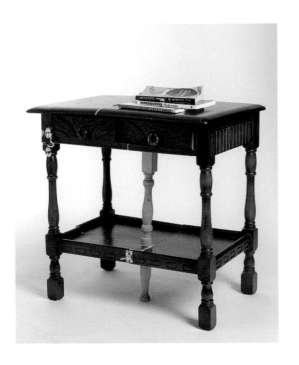
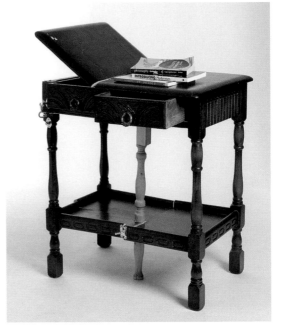
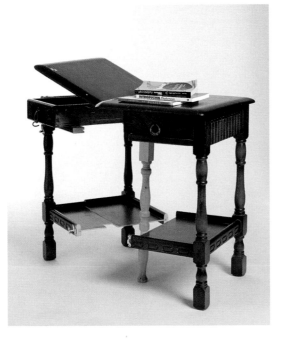
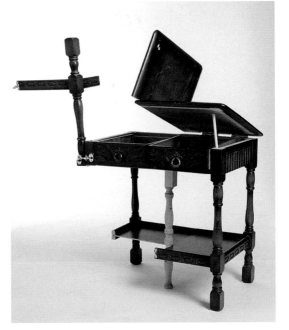

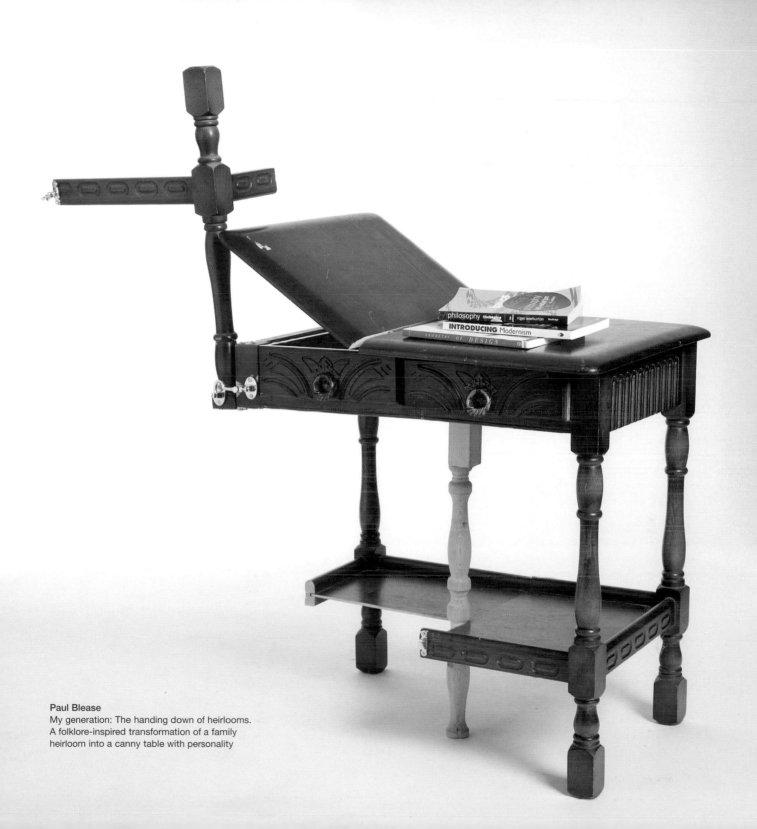

Paul Blease
My generation: The handing down of heirlooms.
A folklore-inspired transformation of a family
heirloom into a canny table with personality

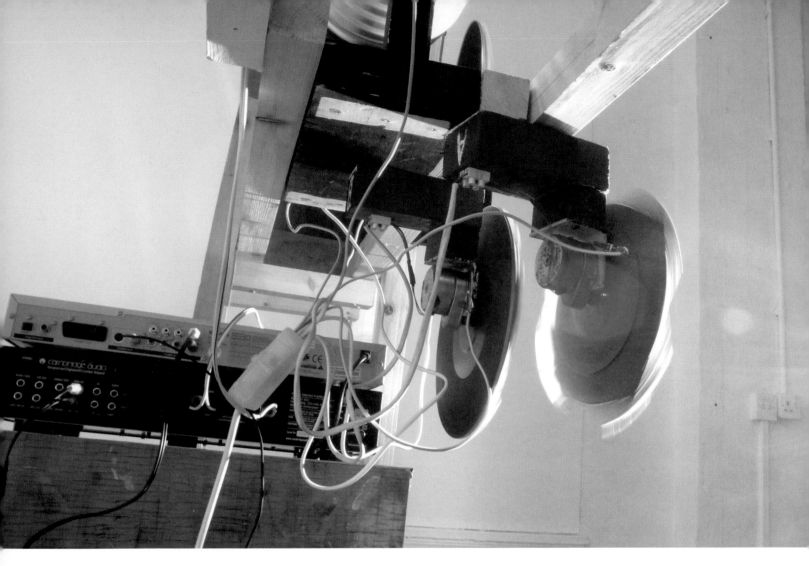

Craig Barnes
Pair of sculptures (detail)

Michael Costello
Yellow Pages

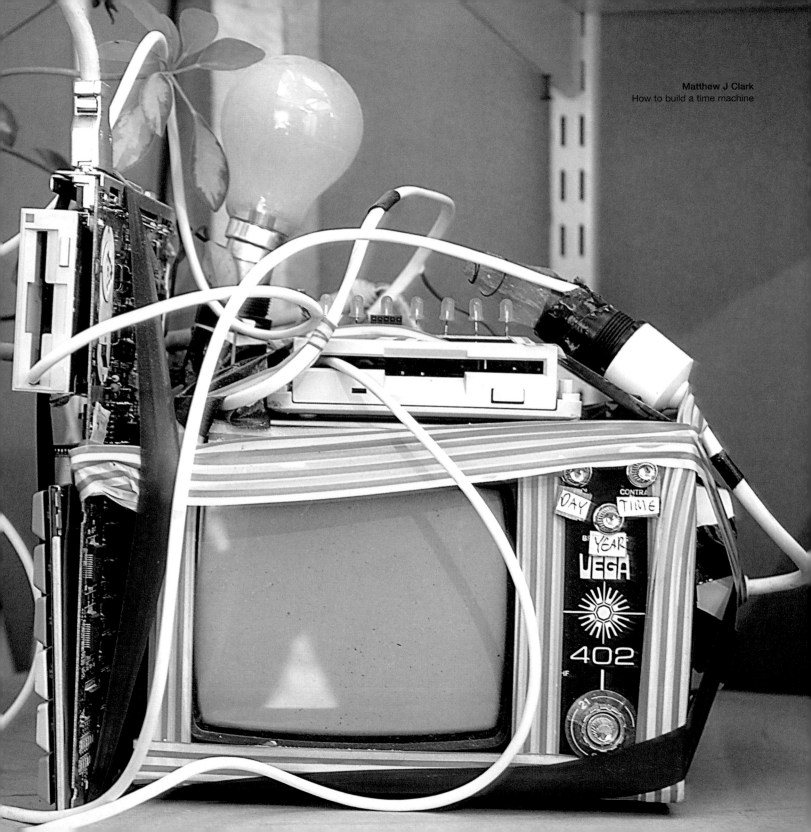

Matthew J Clark
How to build a time machine

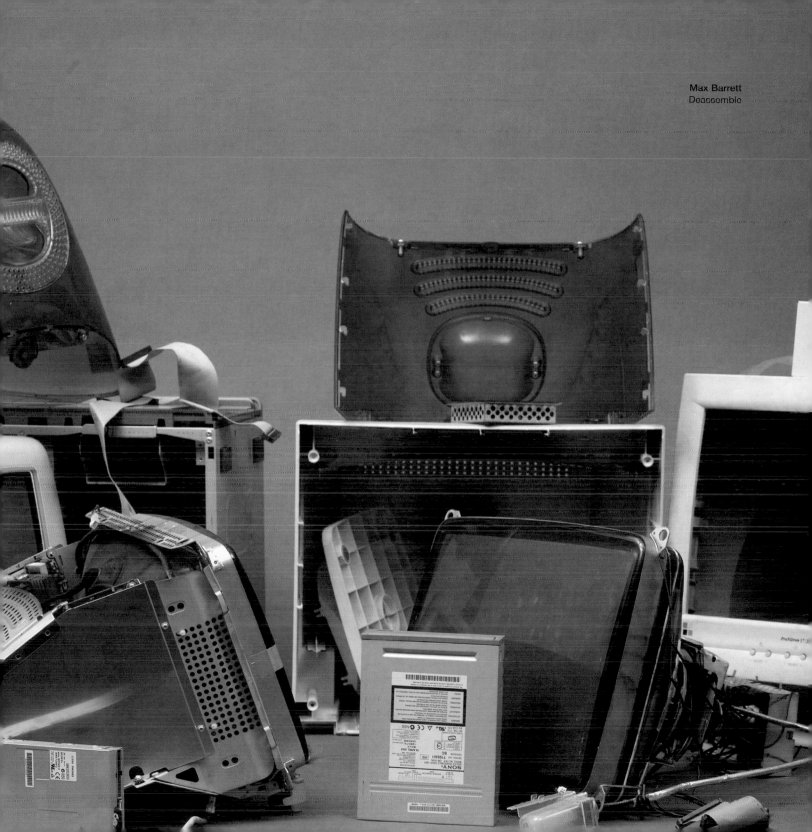

Max Barrett
Deassemble

Harunori Mochizuki
Sound for Fish

Harunori Mochizuki
Sound visualization

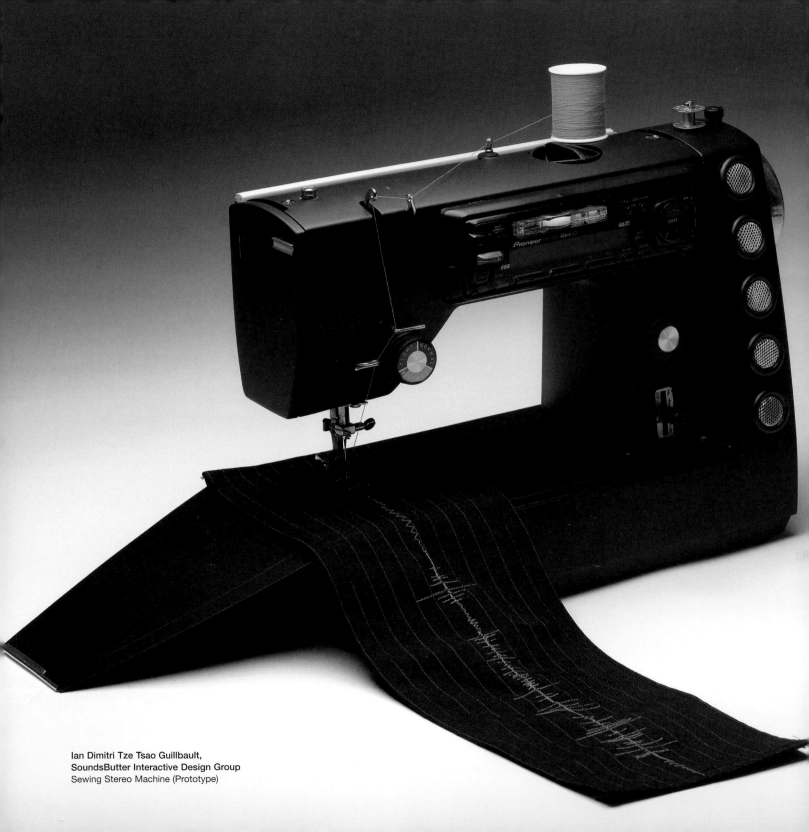

Ian Dimitri Tze Tsao Guillbault,
SoundsButter Interactive Design Group
Sewing Stereo Machine (Prototype)

Li Hon Lam, SoundsButter Interactive Design Group
Tape to Sound Converter

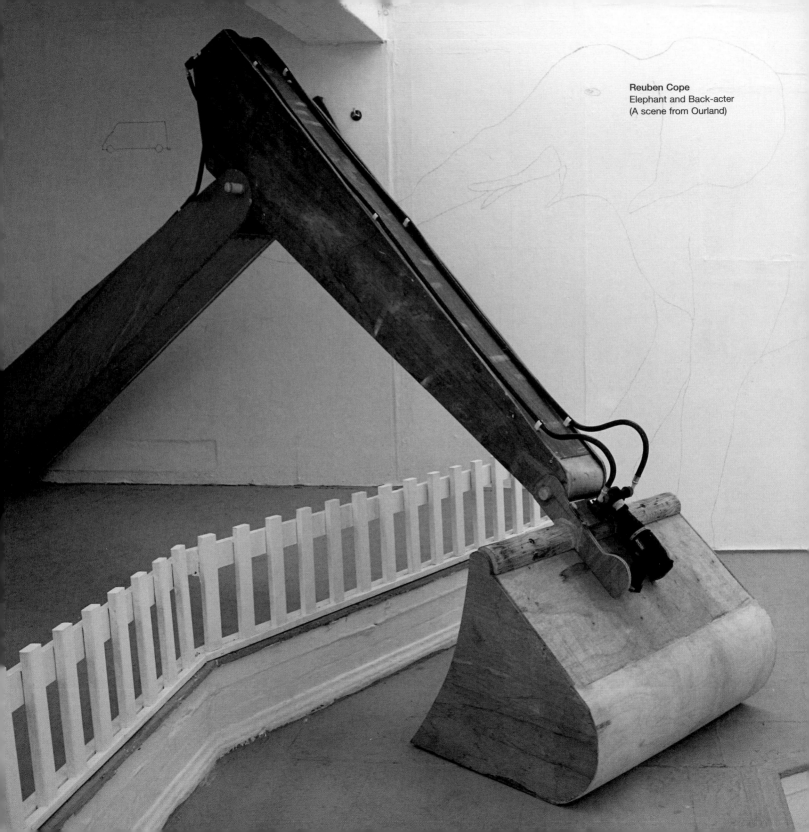

Reuben Cope
Elephant and Back-acter
(A scene from Ourland)

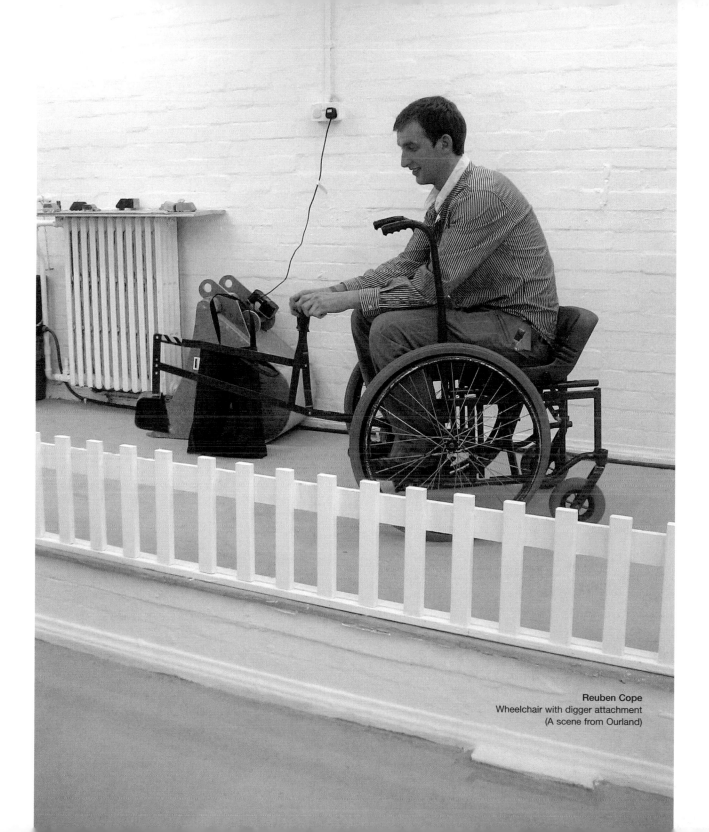

Reuben Cope
Wheelchair with digger attachment
(A scene from Ourland)

02.

Sharp Essentials

Our modern lifestyles – full of overwhelming consumer choice and flashy goods that fight for our attention – are busy enough. But the recent product trend for gaudy, over-embellished patterns, flocked wallpaper and fashion's hard-hitting, 'New Rave'-influenced fluorescent colours is doing nothing to calm down our over-excited visual sense in this seemingly never-ending optical chaos.

This visual bingeing has provided us with a serious hangover for which the only realistic remedy is a radical detox and a return to the core qualities of design. Although the hectic lifestyles remain a reality, the neo-kitsch patterns and loud graphics have been carefully replaced by a much more considered and simple approach to living and design.

'Sharp Essentials' is not only about minimizing and simplifying design, it is about reassessing resources. At a time when raw materials, time and energy are at a premium, how to save them is a must. In this purging process every component of a given product is there for a reason; designers are driven by purpose, with concepts rooted in functionality and simplicity, leaving form to simply follow; almost slide into place.

The old 'less is more' ethos is back and highly relevant with the tough new EU WEEE Directives (Waste Electrical and Electronic Equipment) putting responsibility for taking back and recycling electronic equipment on the producer. This new directive is having a slow but profound effect on how products are designed and engineered. After being criticized by Greenpeace about their lack of deadline for the elimination of some toxic chemicals, Apple have responded with new iMacs using both more natural and easier-to-recycle materials (aluminum, glass and plastic). Many are due to follow suit as the directive's impact is slowly embedded into the fairly long product R&D lifecycle.

Stylistically, 'Sharp Essentials' is about basic and natural materials delivering an element of honesty. It reflects a new approach and expresses a warmer shade of minimalism, which is a logical evolution from the puritan minimal design of old. If there is technology, it is hidden and discreet; if there are graphics they are subdued and calm. Colour-wise, matt blacks, shades of grey and muted whites form the basic palette, with primary highlights such as deep reds punching through the monotone landscape. Personal computers, music players and other digital 'lifestyle' equipment harp back to the Dieter Rams aesthetics of 1960s Braun products, or the Ettore Sottsass famed Olivetti Valentine typewriter that used simple yet elegant interfaces, a minimal number of buttons and squared-off casing. It brings a paradoxical soft-yet-sharp dimension to our electronic gadgets. On the fashion front, a return to sharper and more grown-up tailoring, exaggeration of angles and geometrical experimentation is in evidence, and the colour palette is toned down and monochromatic.

This trend is set to establish itself in 2009/10 with a realization that the days of plenty are behind us and a natural cycle of slow growth will benefit those people who are smart enough to market the values of what is really essential.

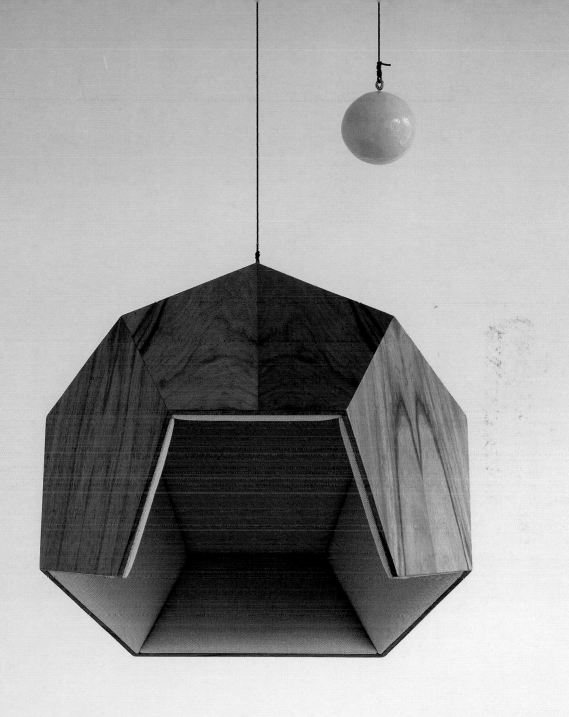

Robert Stadler
Pentaphone, 2006
Photography: Patrick Gries

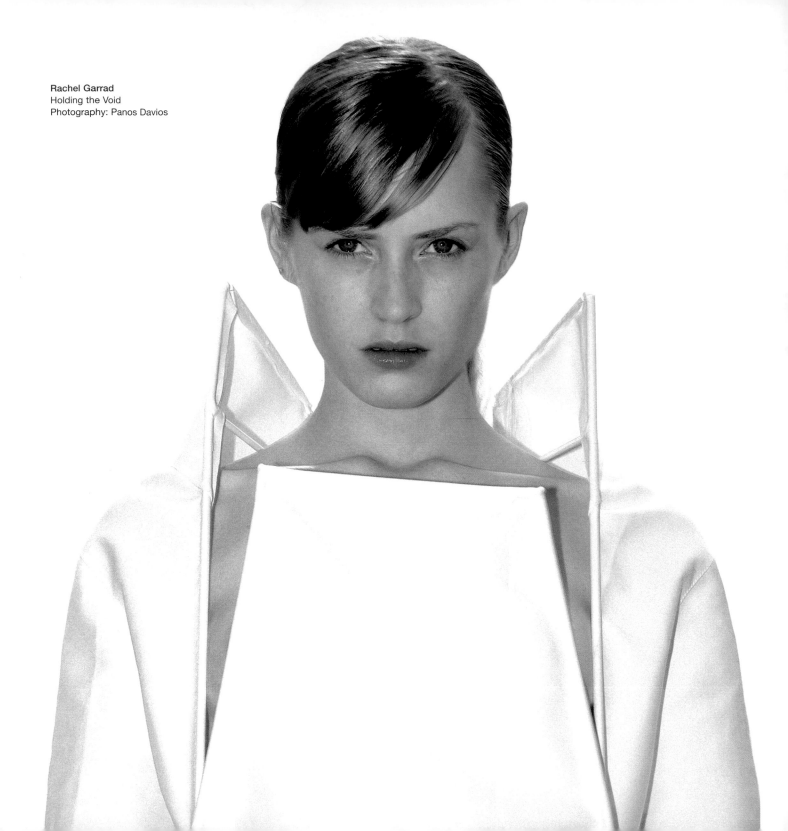

Rachel Garrad
Holding the Void
Photography: Panos Davios

Alia Gargum
Architecture 1

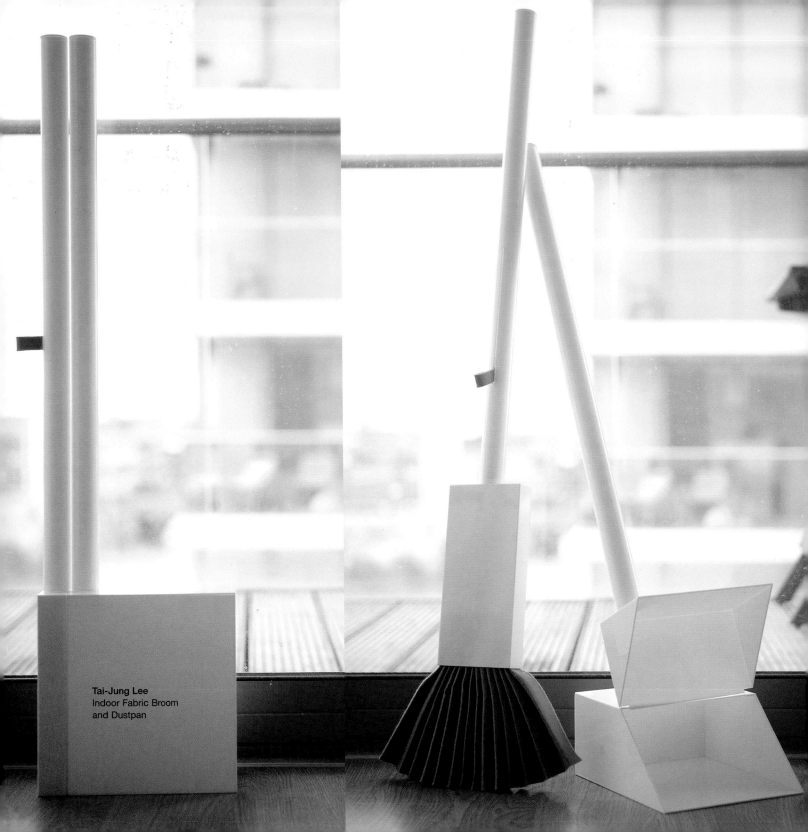

Tai-Jung Lee
Indoor Fabric Broom
and Dustpan

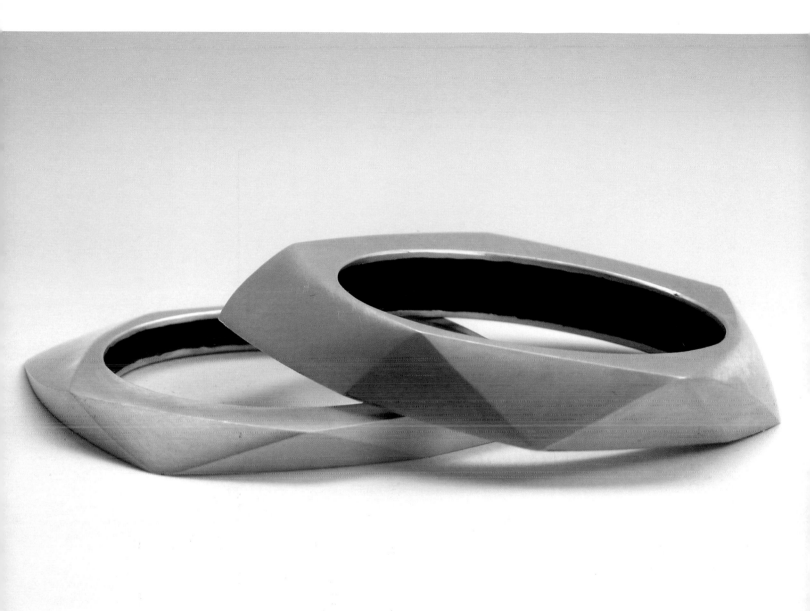

Melanie Eddy
External Facet Bangle Set

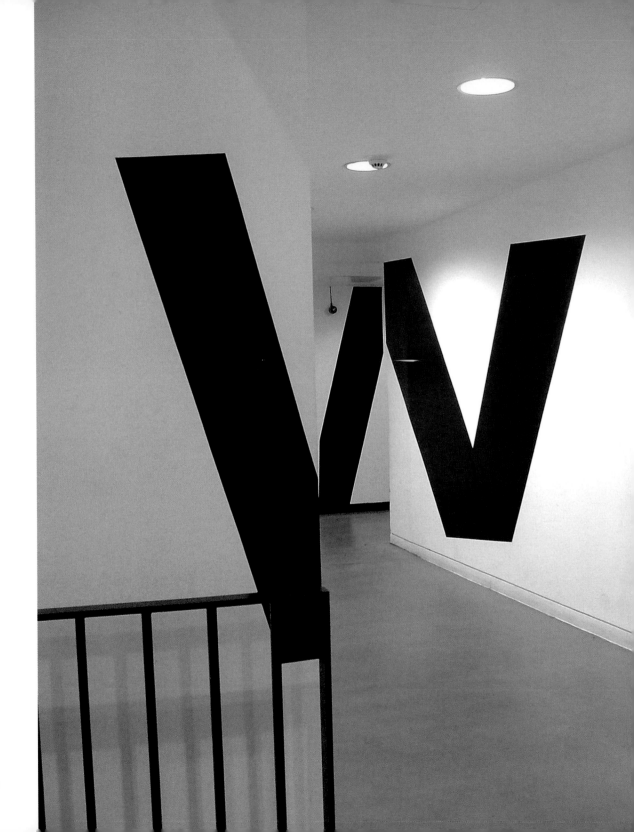

Sophia Ben Yedder
LOST: Space and
Typography, a
Wayfinding Project

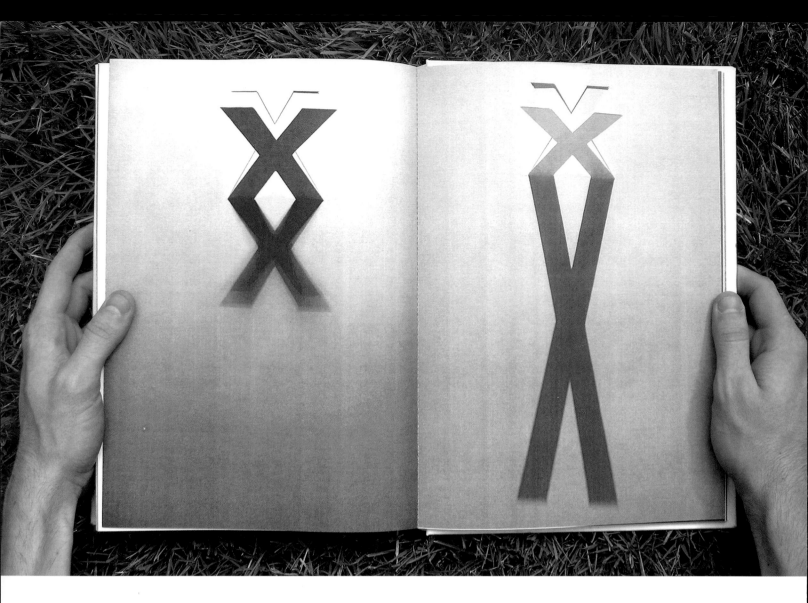

Craig Manley
Time waits for no one

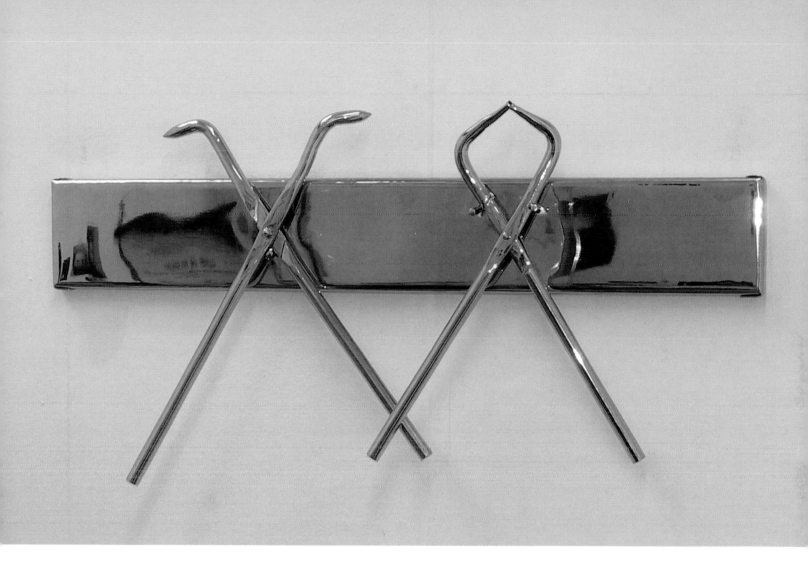

Sarah Cooper
Instruments of Theatre

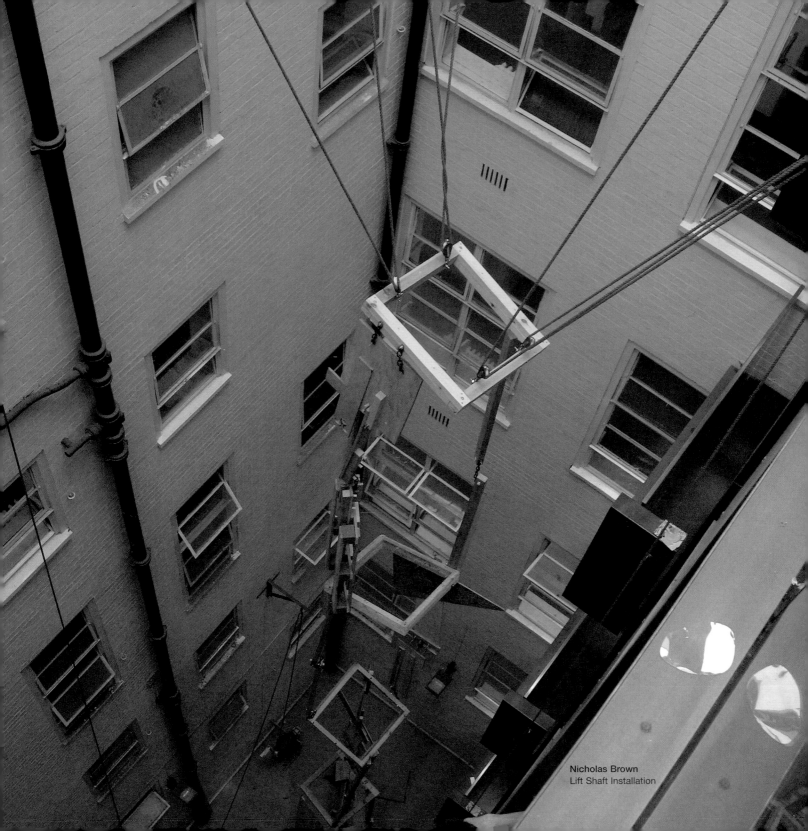

Nicholas Brown
Lift Shaft Installation

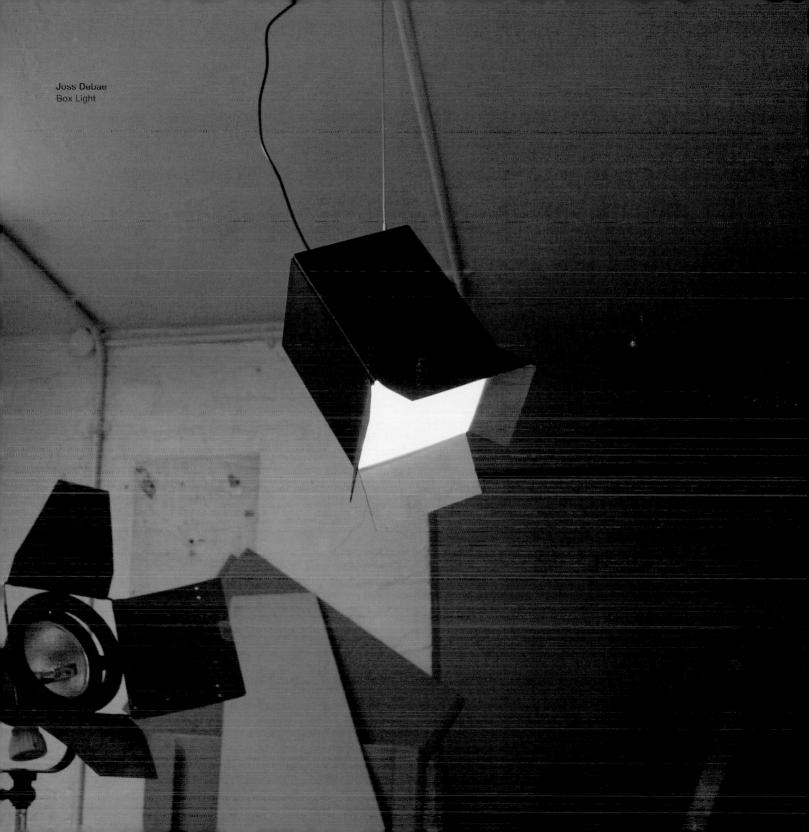

Joss Debae
Box Light

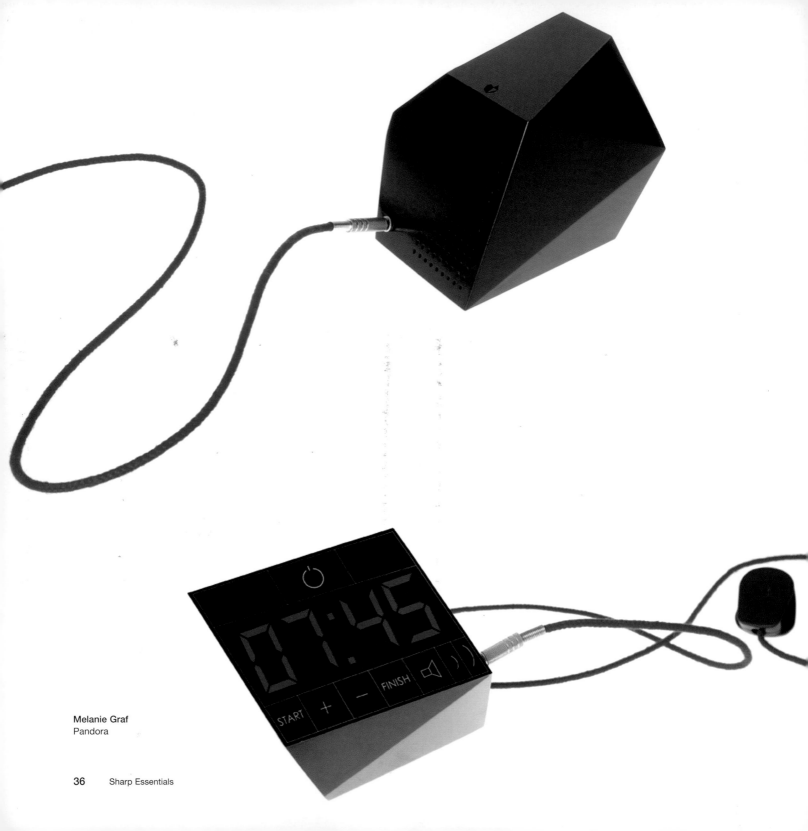

On the display: 07:45

Button labels on device: START + − FINISH 🔊)))

Melanie Graf
Pandora

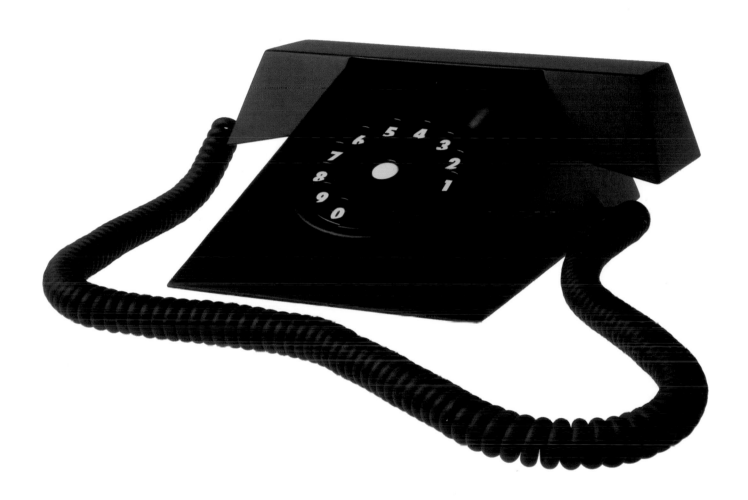

Fabian Nyblom
Spin, mobile phone and
docking station

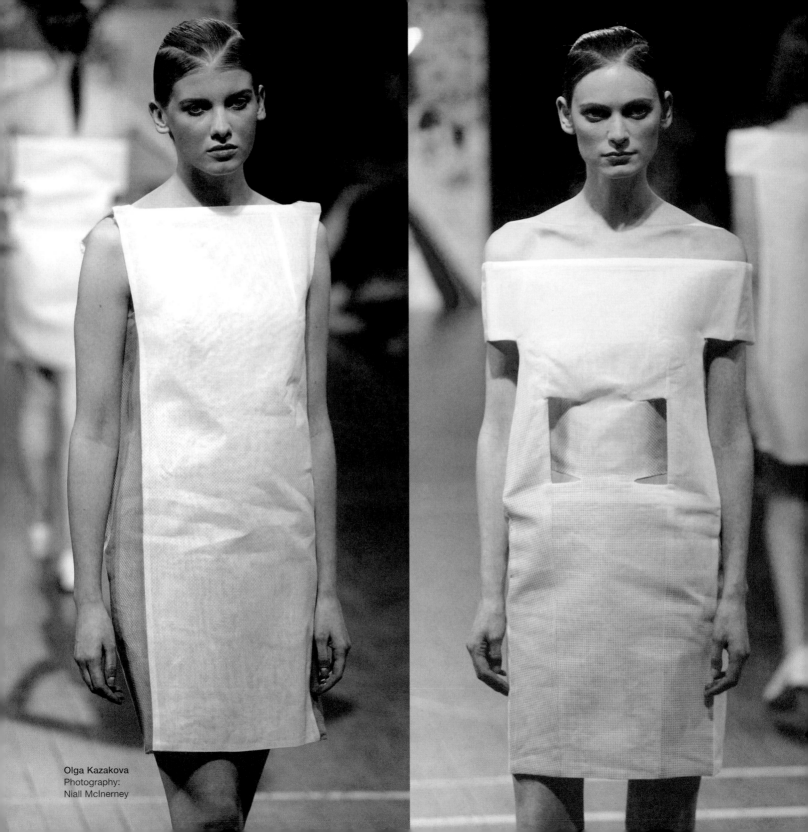

Olga Kazakova
Photography:
Niall McInerney

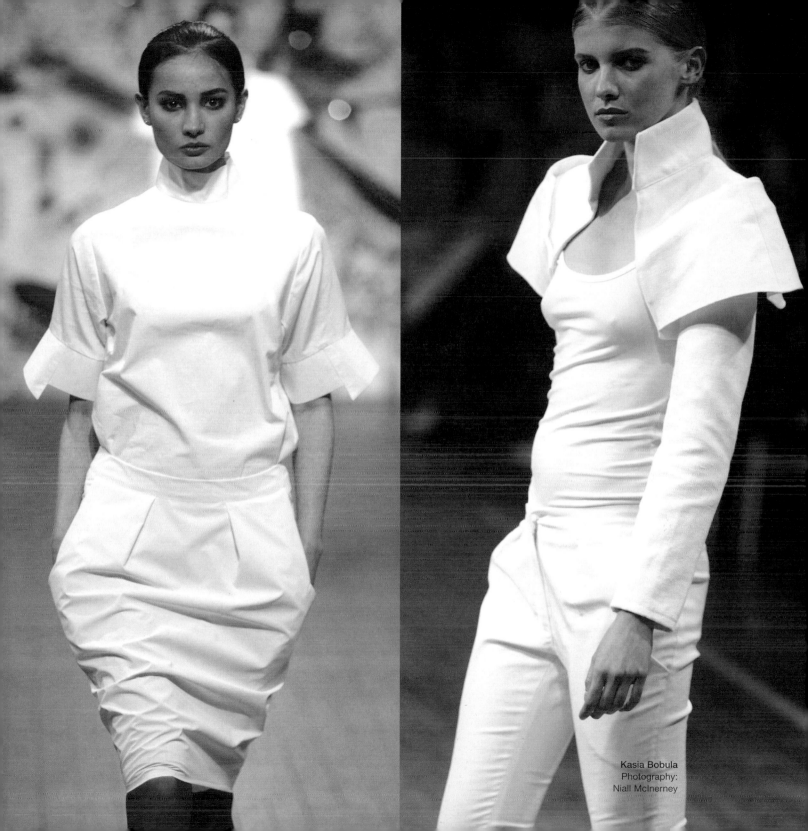

Kasia Bobula
Photography:
Niall McInerney

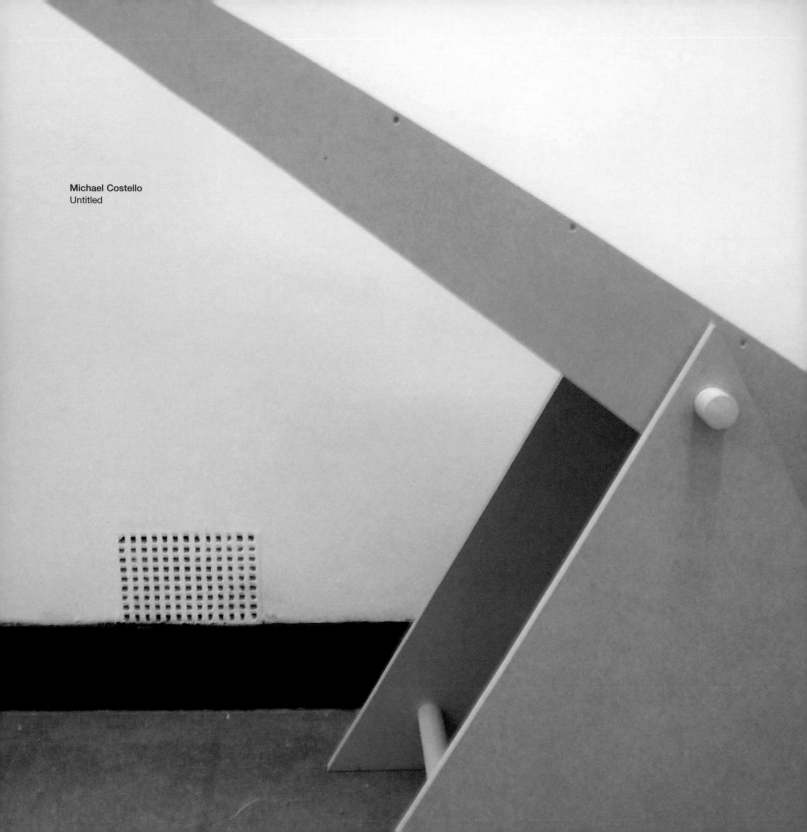

Michael Costello
Untitled

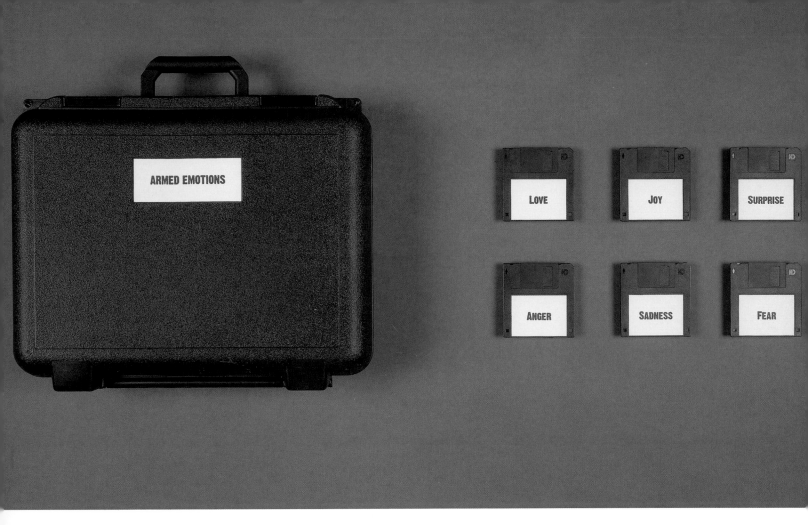

Martin J. Adolfsson
Armed Emotions

Luke Goldsmith
(2xb) false representation

03.

Affordable Beauty

Traditionally, beauty has always come at a price. If you wanted a designer piece of furniture, you had to part with a substantial sum of money. As productivity and technology evolved, the possibilities of mass-manufacturing beautiful and well-executed goods became a reality. Most recently, the landscape of manufactured goods has culminated in a situation in which all established understanding and assumptions about what constitutes a beautifully made object have to be reassessed. Luxury companies have been challenged by mass production of cheaper and sometimes better-quality products. Demanding consumers expect affordable luxuries in order to feel valued and empowered in their regular shop outings. Global mass-market companies have added 'luxury' lines or associated themselves with high-end designers.

However, running parallel to this, recent concerns with sustainability and the environment have challenged our perception of mass consumption and our modern throwaway culture. There is now constant pressure to reduce waste and consider the materials we use. Eco-friendly solutions are still very slow to demonstrate how desirable biodegradable and recycled products can be, even though the continuing environmental problems don't look as if they will be solved any time soon. Governments worldwide are gradually imposing action to combat such problems. The worldwide campaign to ban free plastic carrier bags is gathering pace in many countries and cities. China, whose shopkeepers hand out as many as three billion plastic bags a day, has become the latest country to ban the practice. The drive to outlaw and get rid of

what was once considered mundane and common could result in these very materials becoming highly valuable again.

Instinctively responding to this new climate, designers and artists are rediscovering and cherishing what was once considered valueless. 'Affordable Beauty' demonstrates that beautiful doesn't have to come at a price. Designers re-use, recycle and repurpose found objects, disposable packaging and everyday materials. Rubbish is recycled and put to good use in new contexts. Paper cups are used as the blank canvas for signage, while the notoriously drab plastic carrier bags, which until now have mainly been filling up landfills and freely roaming about the urban landscape, are used to diffuse light bulbs, highlighting not only the creative potential of recycling but also how beautiful everyday objects can be. By mixing the visual languages of luxurious Louis XV tables and ornate detailed silverware with cheap mass-produced materials and processes such as EPS (expanded polystyrene) and injection moulding, what would have once been the preserve of the rich is now made beautifully affordable for everyday use, regardless of wealth. For some, however, these designs will work as a satirical response to today's throwaway culture.

'Affordable Beauty' sits comfortably between extreme luxury and mass pretend opulence, carving a new and growing niche for design-savvy and cash-conscious consumers seeking an alternative when buying beautiful objects.

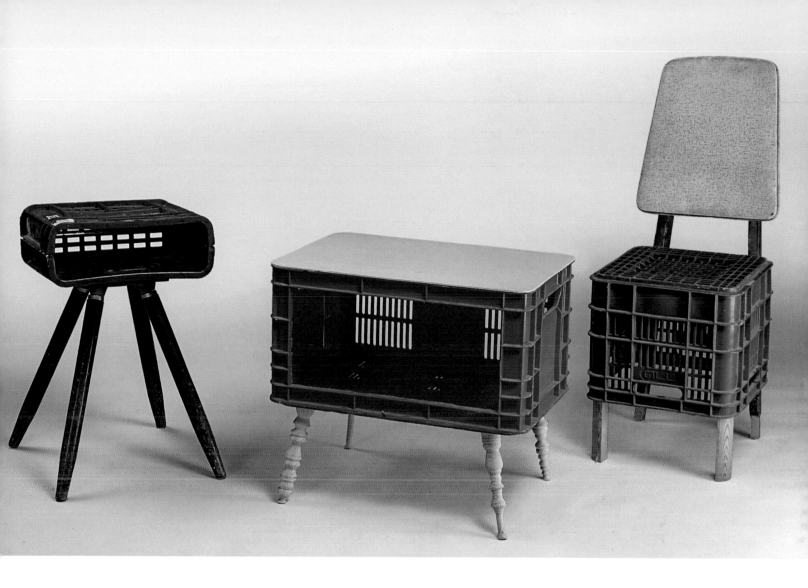

Naty Moskovich
Box life
Secondary life for a daily object

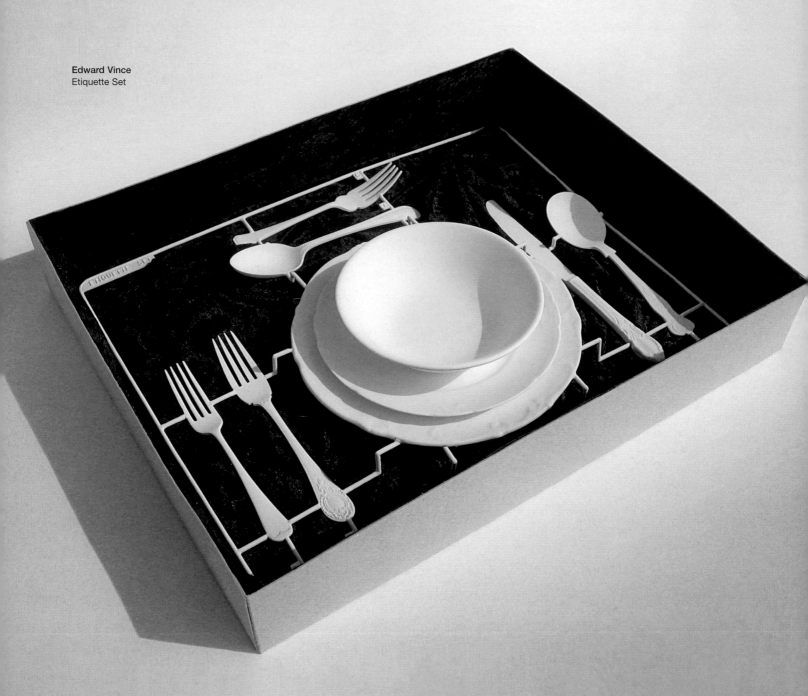

Edward Vince
Etiquette Set

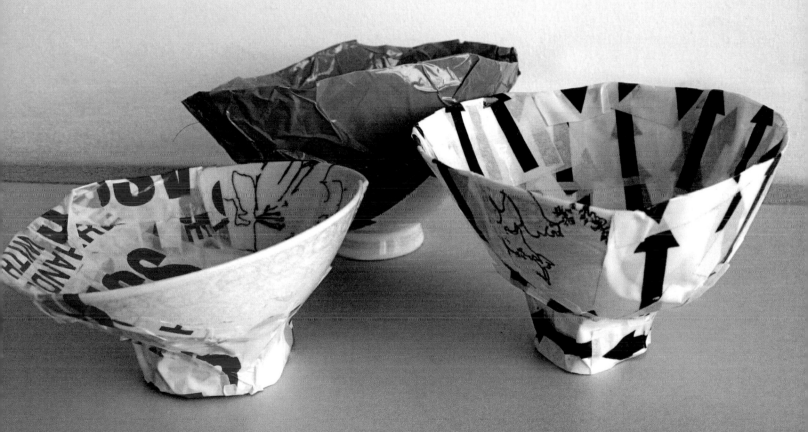

Sonia Barbate
Recycle, London!

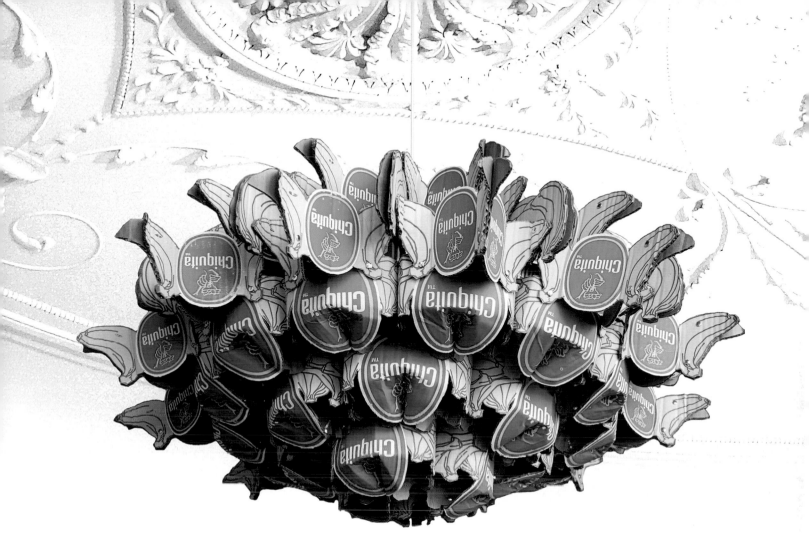

Anneke Jakobs
Chiquita Chandelier

Next page:
Thibaud Hérem and Jean Jullien
Cyber Café

CYBER CAFÉ

STAFF WANTED

FIRST YEARS ONLY

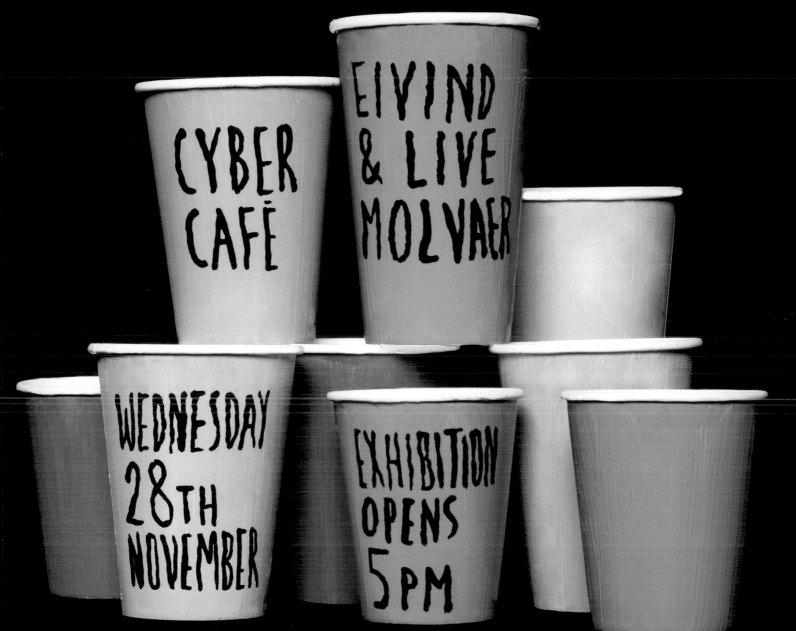

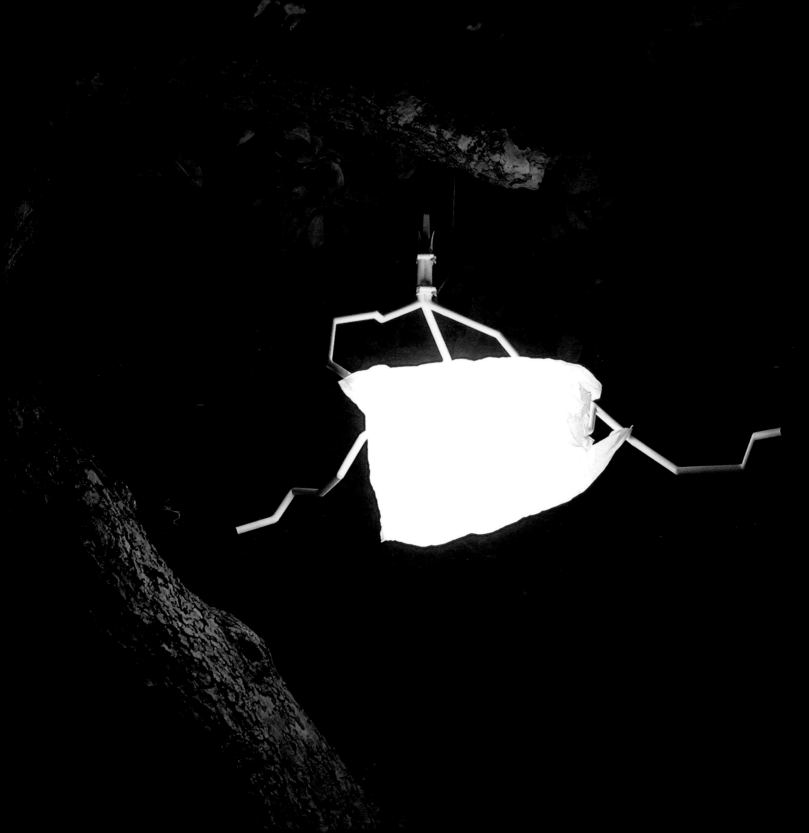

Edward Vince
Bag Stuck in a Tree
Light

Arianna Osti
'We make the
world we live in
and shape our
own environment.'
M. Orson Swett

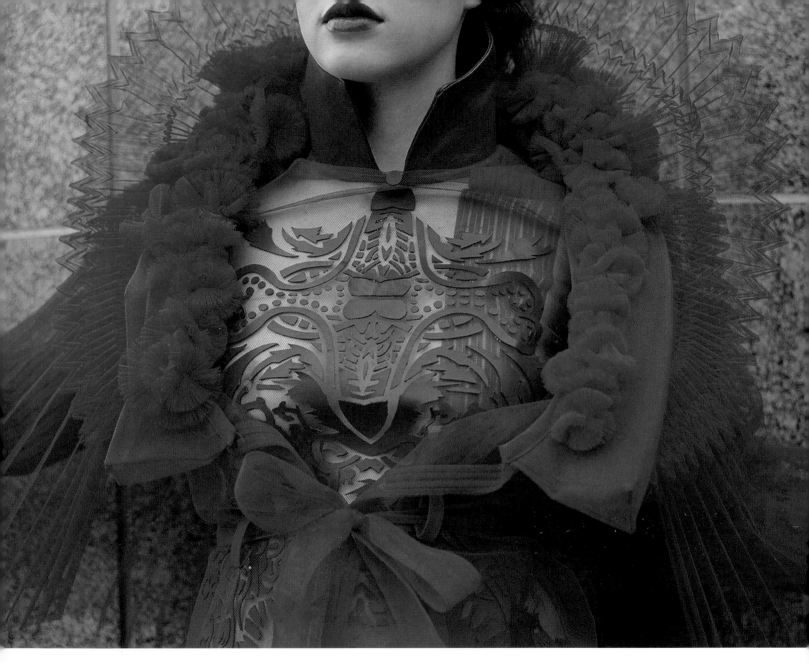

Jack Isenberg
Photography: Brian O'Callaghan
Styling: Gareth Lindsay

Heather Smith (right)
Birch plywood wall panel in
'Oval Lattice' design

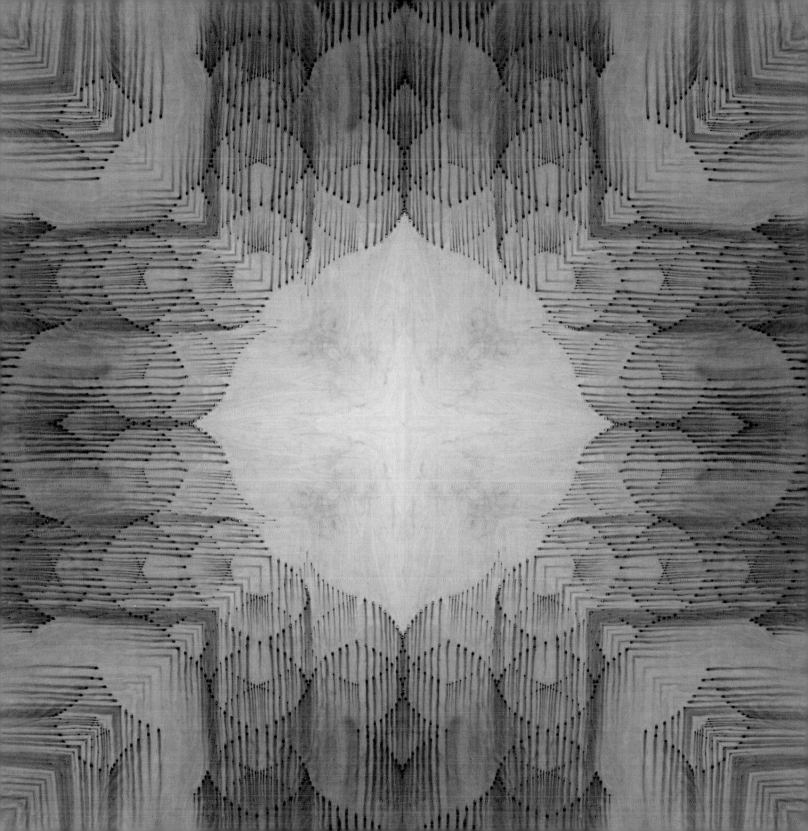

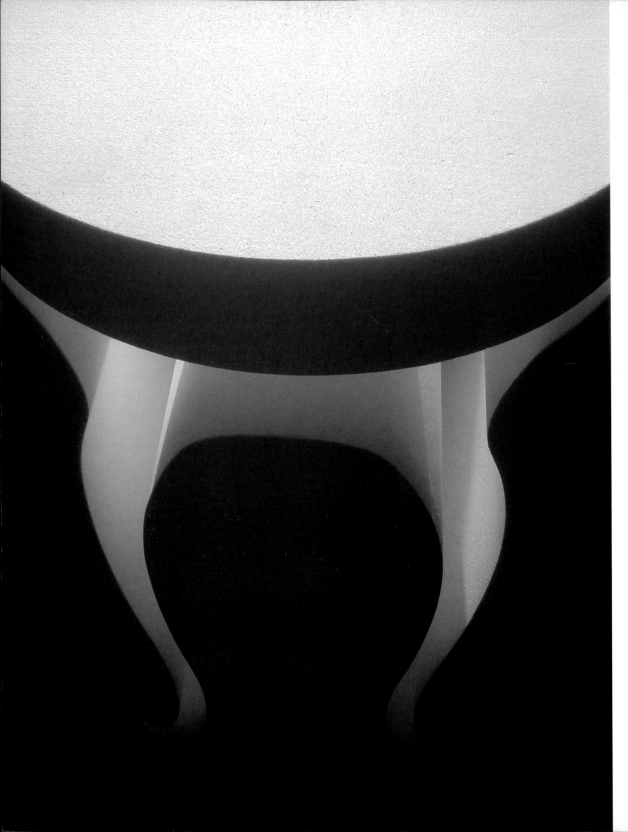

Gerasimina Sarantopoulou
Louis Table

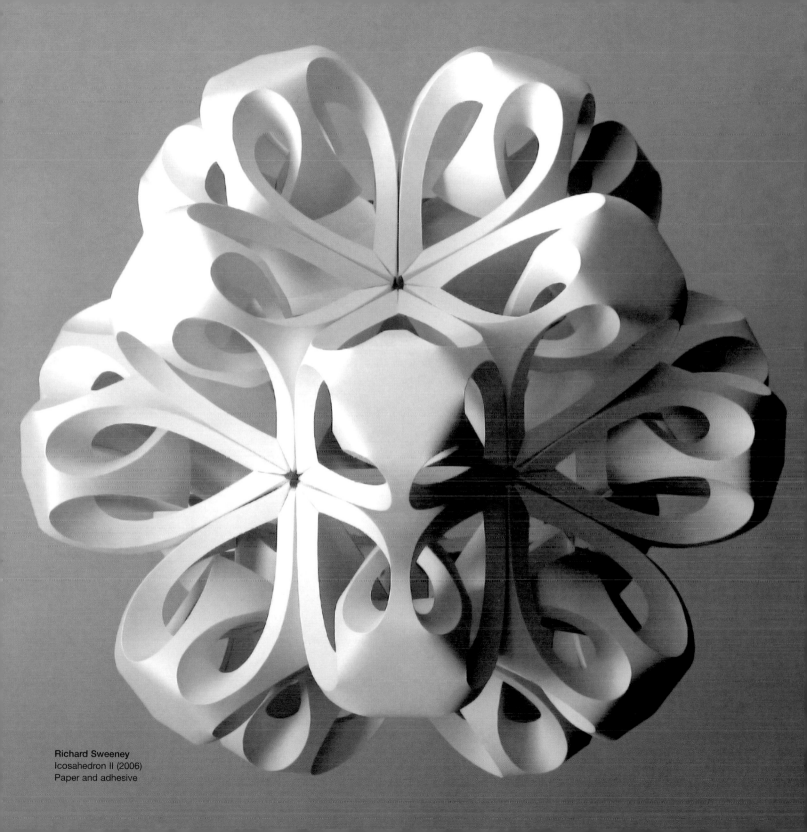

Richard Sweeney
Icosahedron II (2006)
Paper and adhesive

Neda Niaraki
Fast Food Fashion

04.

Apocalyptica

Is our ever-increasing compulsion to consume, our addiction to oil, and a quest for a better quality of life slowly painting mankind into a dark corner? Alarm bells are ringing from every corner, be it the environment, national security, social instability, immigration, crime or the economy. Add to this an almost suffocating information overload and the increasing globalization of the media, which magnifies and in some cases distorts the world's problems. Consciously or unconsciously, the media can provide, for those who seek it, a platform for a warped and paranoid vision of impending doom. Although Armageddon has been a recurring theme since Biblical times, the end of the world feels that much closer than it did previously. *The Bulletin of the Atomic Scientists* (BAS) has moved the Doomsday Clock two minutes closer to catastrophe for the first time since the terrorist attacks of 9/11 (nuclear arms and the effects of climate change are the main factors that have driven the clock to five to midnight). Finance experts predicted a recession period where global markets would go through a phase of much-needed readjustment following overvalued equity and too much emphasis on consumerism. They have guessed right, with the credit crunch now in full swing.

Probably driven by the vision of a near future where any commodity is hard or virtually impossible to get, designers and artists are seen stockpiling whatever they can get their hands on. They create make-shift 'Mad Max' installations, borrowing and scavenging spare parts and tying them together with rope and other improvised fixtures. Fashion

designers, artists and filmmakers reveal in their work a bleak, post-apocalyptic view. In their world everything is dark, dead and burnt out. In our western societies, where real hardship has not been seen for more than 60 years, our creative minds are considering what if 'the world as we know it' would end? This question hangs over us like the Sword of Damocles, driving experimentation and fantasy scenarios where darkness and desolation reign. 'Apocalyptica' is a more extreme, abrupt and chaotic version of the 'Sharp Essentials' trend; pushing the limits, breaking down our affluent and comfortable lifestyles to pieces, creating everything from nothing, reclaiming and using elements in ways in which they were not meant to be used. This experimentation by self-imposed necessity delivers challenging and thought-provoking concepts where inventiveness prevails.

How could business develop in such a nihilistic scenario where scavenging is preferred to consuming? Some radical-thinking economists suggest models of zero growth as potential solutions to balance the ups and downs of capitalism. They argue that growth as we know it is not sustainable simply because we have reached a tipping point that if left unchecked will have catastrophic, almost apocalyptic consequences. Will consumerism, in the traditional sense, die out as people figure out new ways of surviving, recycling and reusing materials?

Masayoshi Fujikawa
Untitled, 2007

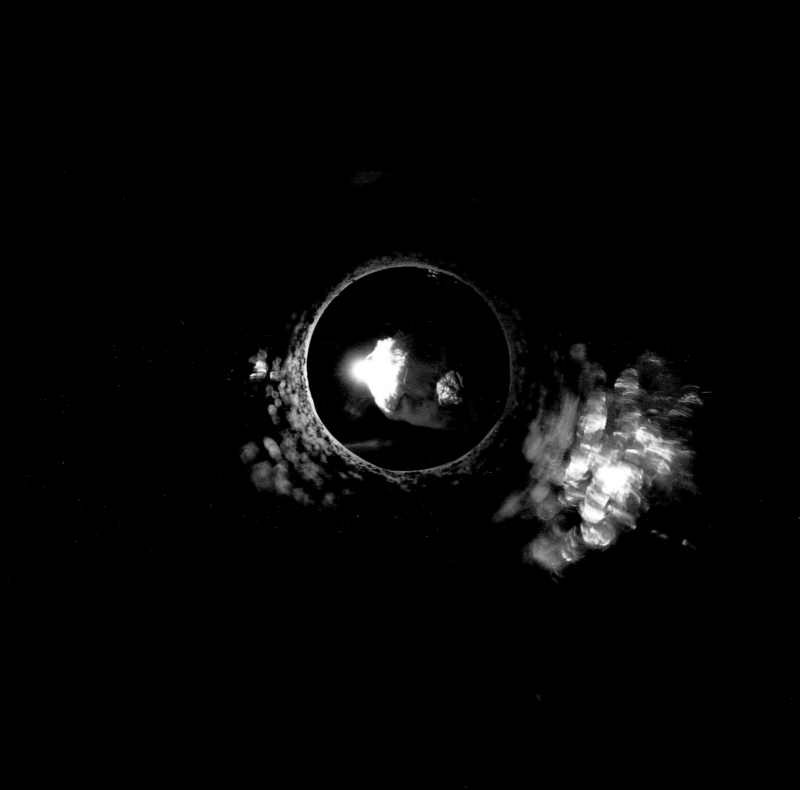

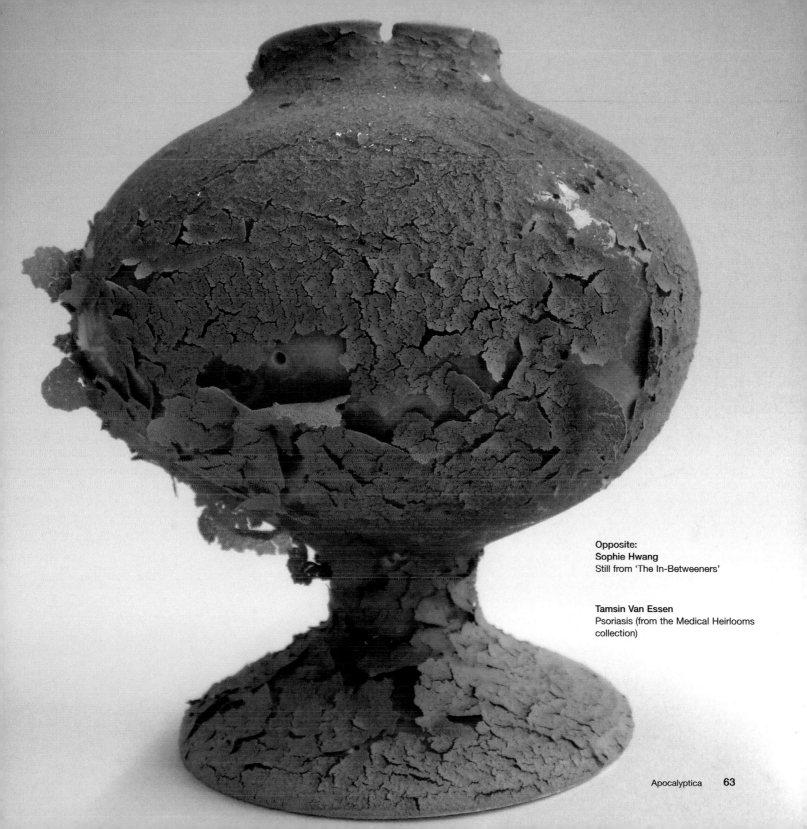

Opposite:
Sophie Hwang
Still from 'The In-Betweeners'

Tamsin Van Essen
Psoriasis (from the Medical Heirlooms
collection)

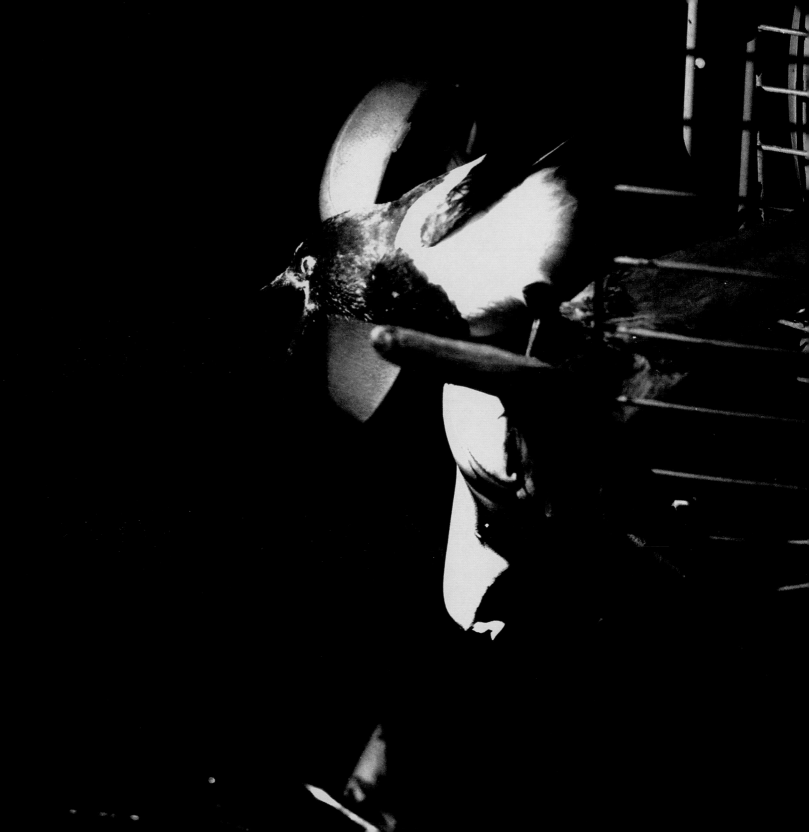

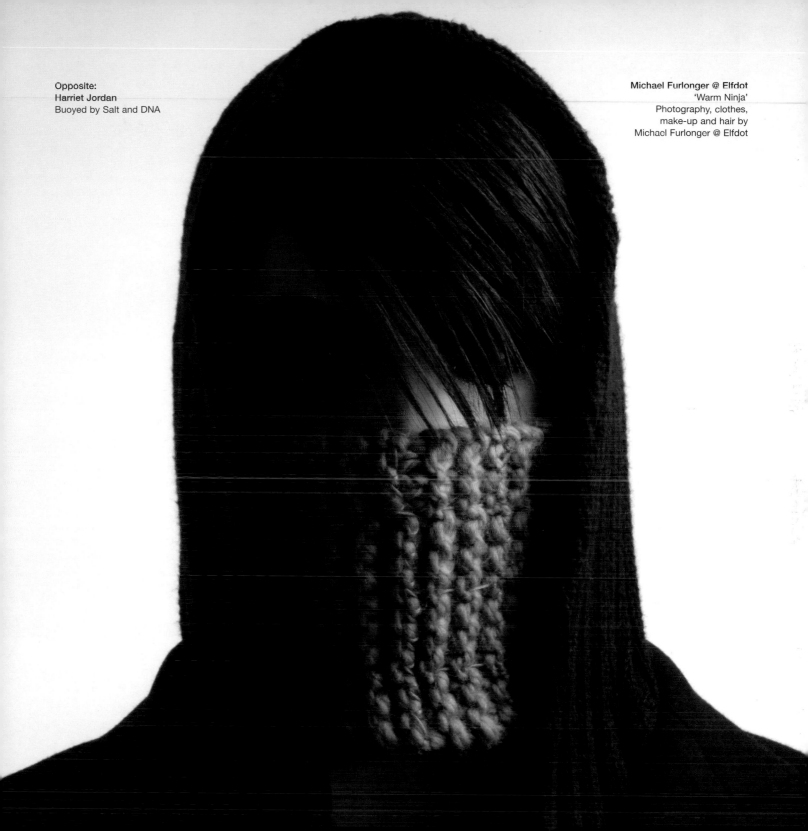

Opposite:
Harriet Jordan
Buoyed by Salt and DNA

Michael Furlonger @ Elfdot
'Warm Ninja'
Photography, clothes,
make-up and hair by
Michael Furlonger @ Elfdot

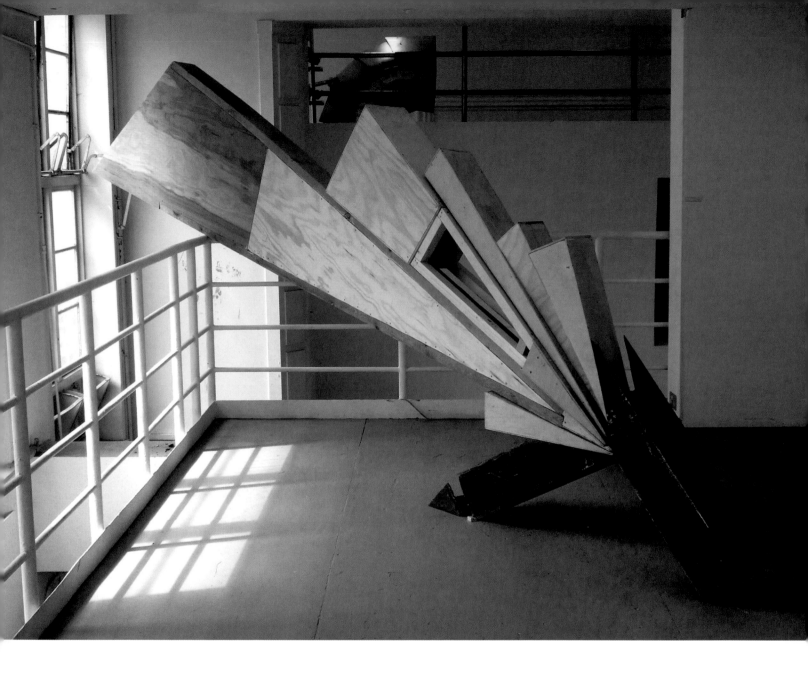

Jamie Bowler
Splice (2007)

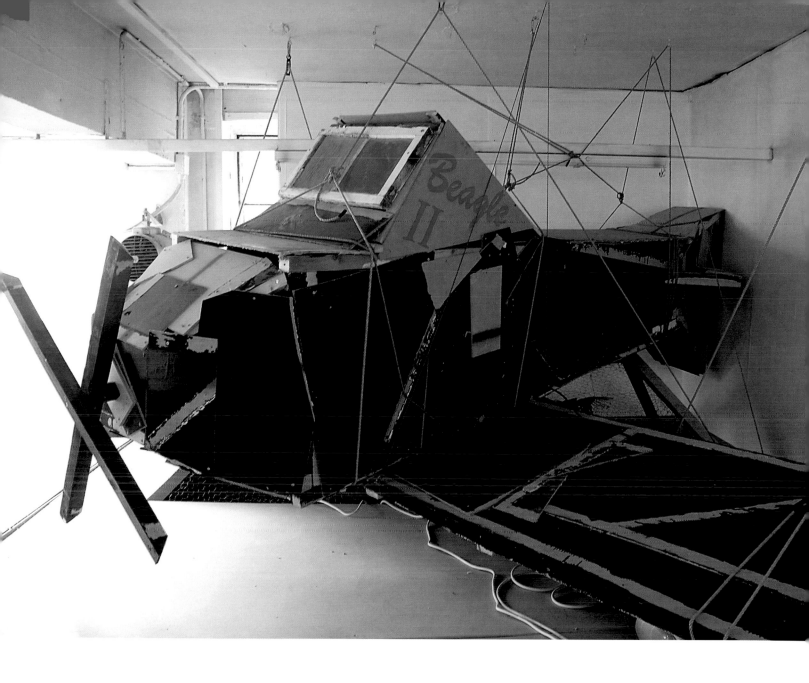

Matthew J. Clark
The Voyage of Beagle II

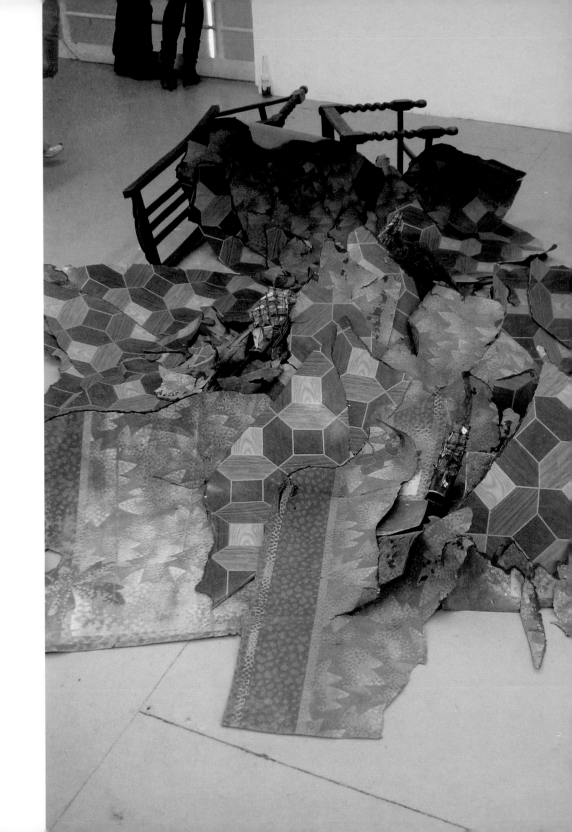

Julie Elgar
Untitled
Lino, chairs, model ships

Reuben Cope
Will This Be the End?
(A scene from Ourland)

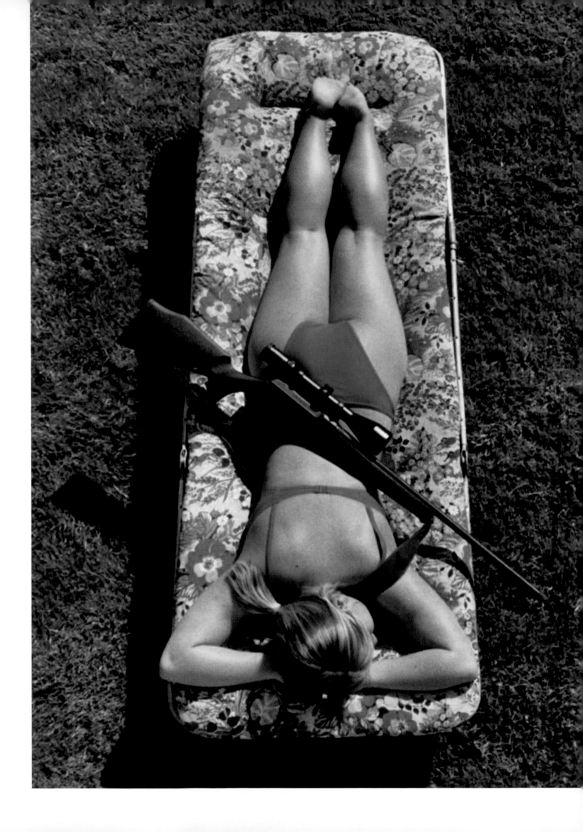

Eivind Søreng Molvaer
Anti-War Protest
Part of a bird's eye
perspective project.
With thanks to Tuva Magritt

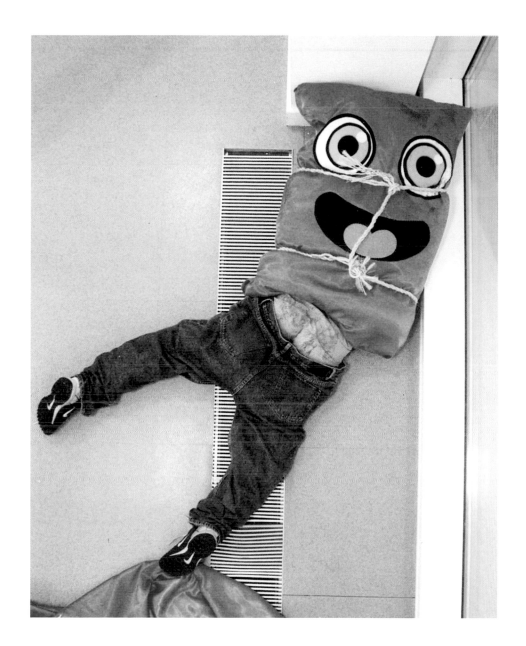

Matt Lippiatt
Scumtrap Figure # 1

Felicity Marshall
Faceless Boy

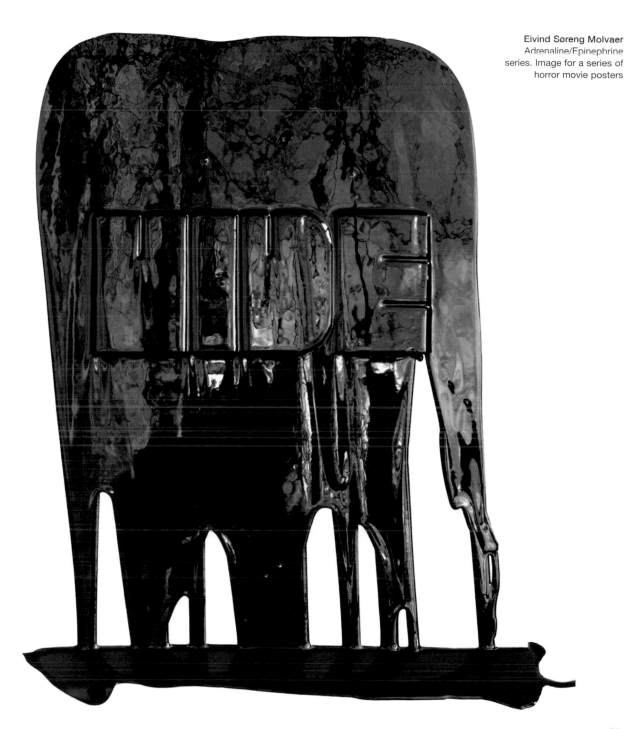

Eivind Søreng Molvaer
Adrenaline/Epinephrine
series. Image for a series of
horror movie posters

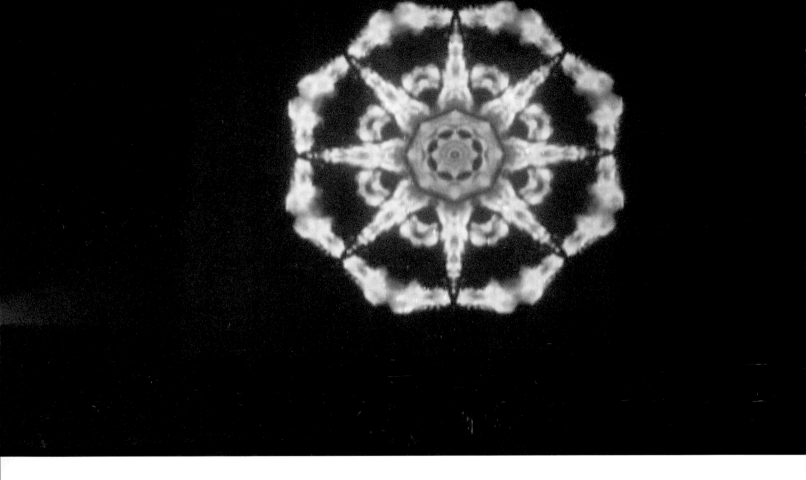

Tom Estes
Utopia

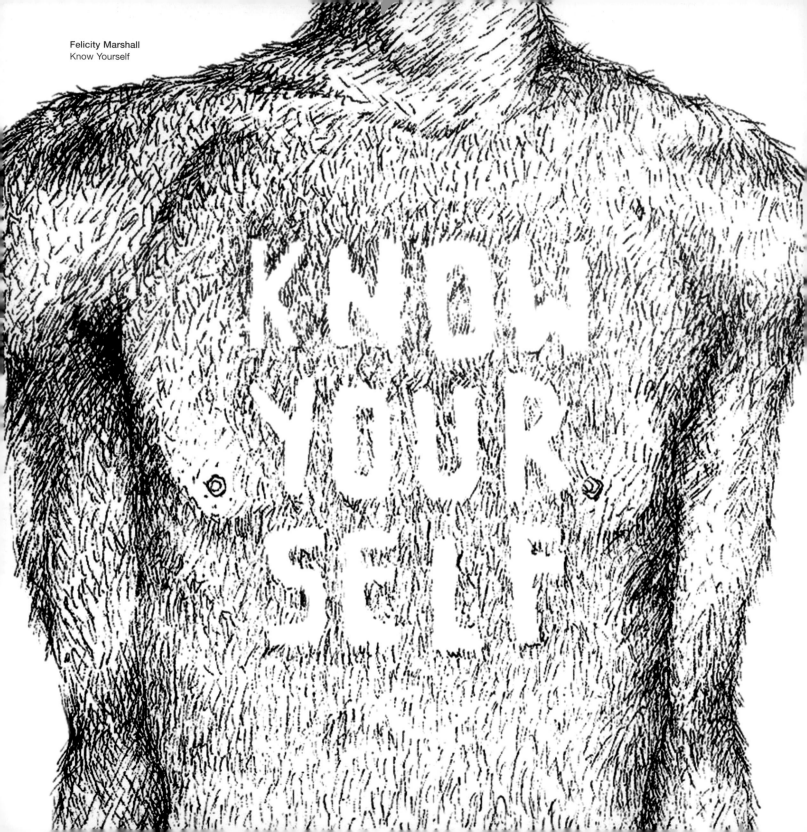

THE LAST HUMANS WILL BE AS NAKED AND STUPID AS THE FIRST. - ANATOLE FRAN[CE]

Rafal Benedek
Archive of the End of the World

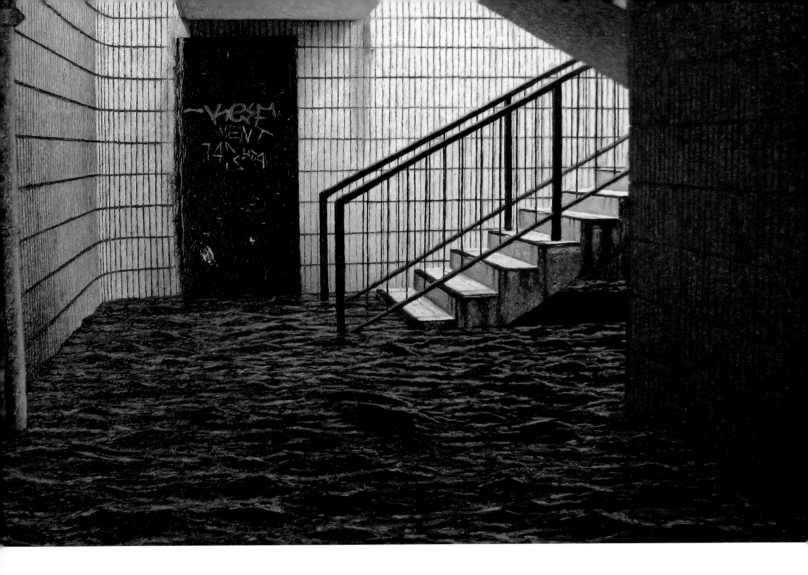

Chris May
Third Floor
Oil on canvas, 2007

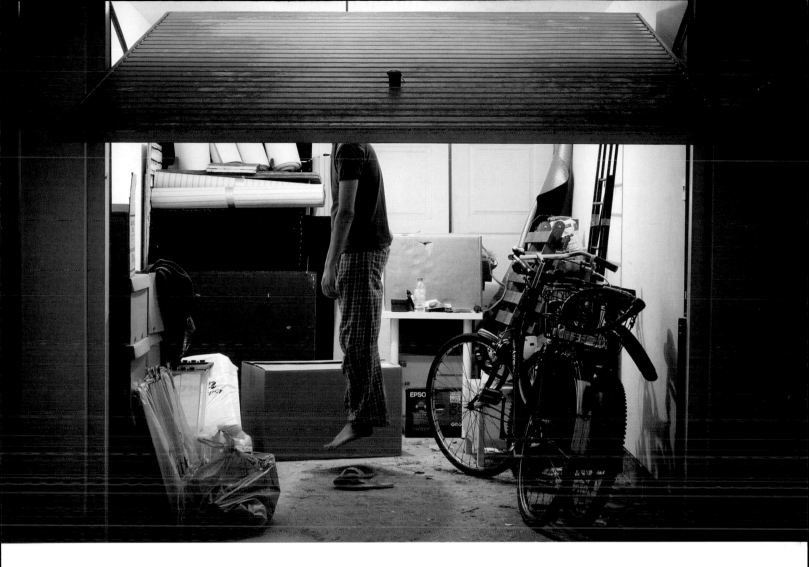

Sakis Kyratzis
You Lose
(part of My Death series)

05.

Nomadic Solutions

Ask any architect or developer building in and around cities what is the most important factor when considering new dwellings. Density is probably the top of their list. The American-inspired dream of low-rise detached suburban house with generous front and back gardens is not sustainable in the 21st century. Sprawling suburbs generate more traffic, eat up green fields and lengthen the distance from home to work substantially. A saturation point in urban sprawl seems to have been reached, creating a 'perfect storm' scenario for any issue related to space, travel and storage.

Younger urban dwellers are also feeling the financial pressure with education costs and highly priced accommodation. Frightening property prices have encouraged squat living in recent years, and in Paris, where one in ten flats is empty, buildings were made available for students to legally squat. Yet affordable space is still at a premium.

With constant innovation in mobile technology, from 3G to WiFi to the Blackberry, plenty of businessmen have been leading the way with their nomadic digital lifestyles. You can now work, eat and potentially sleep anywhere in the world, regardless of whether it is a hotel lobby or a park bench, and still be connected – and the trend looks set to continue. WIMAX, a technology that potentially provides wireless data over long distances and which is currently being trialed in key cities, will soon have the same impact on wireless technology as broadband has had on the Internet.

Designers focus on developing concepts that fit the needs of inner-city living. They can utilize outdoor space and alleyways in a similar way to the homeless, using whatever is around to create and customize a new space; a temporary shelter. Product designers focus their attention on creating space-saving solutions for those living in cramped conditions. One popular method is to use modular furniture systems and objects with secondary functions to maximize the efficiency of available space. This trend is about adapting to our ever-changing compact lifestyles. Rather than trying to avoid the issue, designers are proactively devising new solutions around our shrinking and mobile space.

Travelling is another area where space is fast becoming a premium. No-frills airlines are now looking at novel ways to save money or charge extra. Luggage is an easy target. Packing cheap can be a challenge, especially when going away for a lengthy period. On the roads, as the highways become increasingly congested and easy parking is a thing of the past, the popularity of smaller cars increases with the likes of the Mini, Fiat 500, G-Wizz Smart and most recently Tata's Nano.

Companies able to deliver products that are convergent and multi-functional will attract an increasing pool of 'space-challenged' consumers. Earthly space, and how to save as much of it as possible, is the new challenging frontier for designers and companies alike.

easySleep

easySleep

easySleep

easySleep

easySleep

Pintu Gates C21-C27

Pintu Gates C21-C27

Daniel Fernandez
A cluster of Easy Sleep
pods in an airport concourse

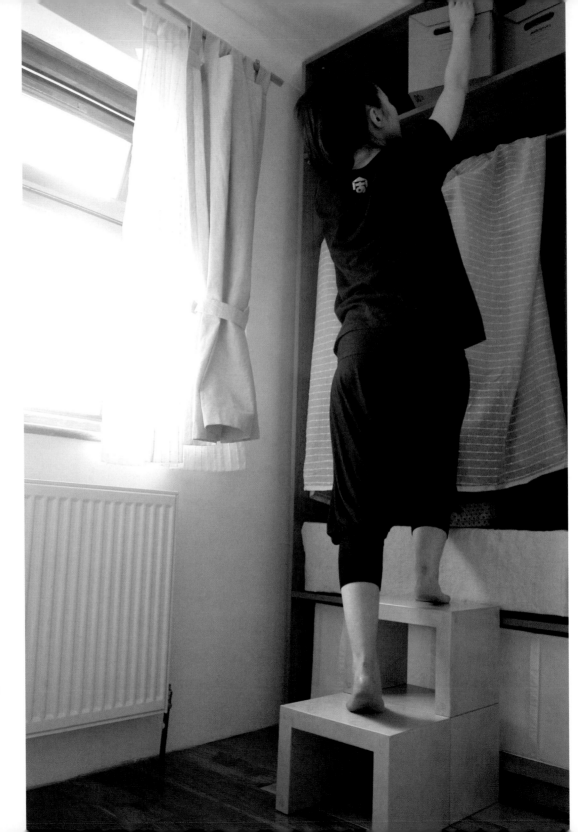

Zhen Yuan Liu
Magnetic Stool
An easy and secure way to
make you taller. Functions
as a bedside table
(opposite)

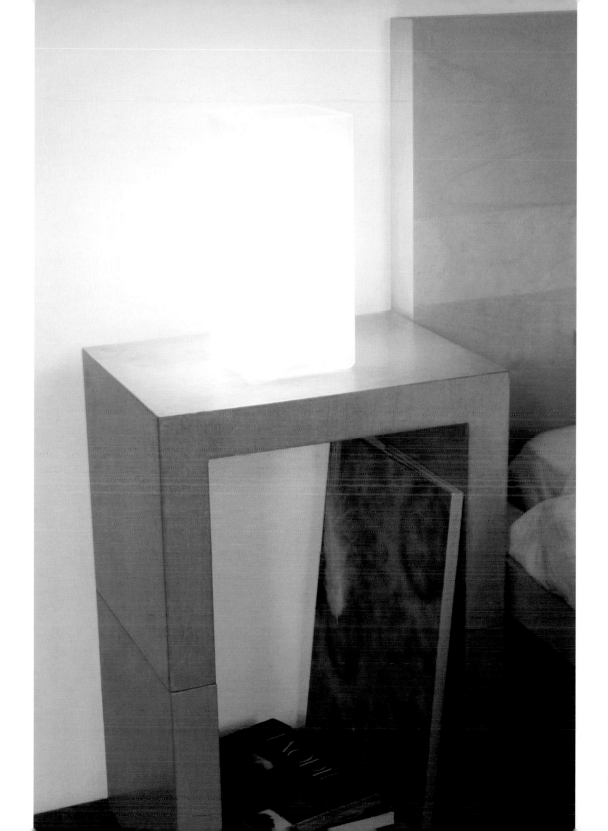

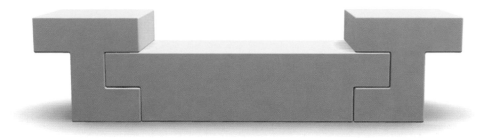

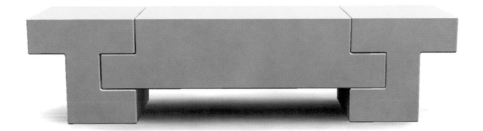

Bonk Kyu Song
2 + ½ Chairs, 1 Table,
Sofa and Bed

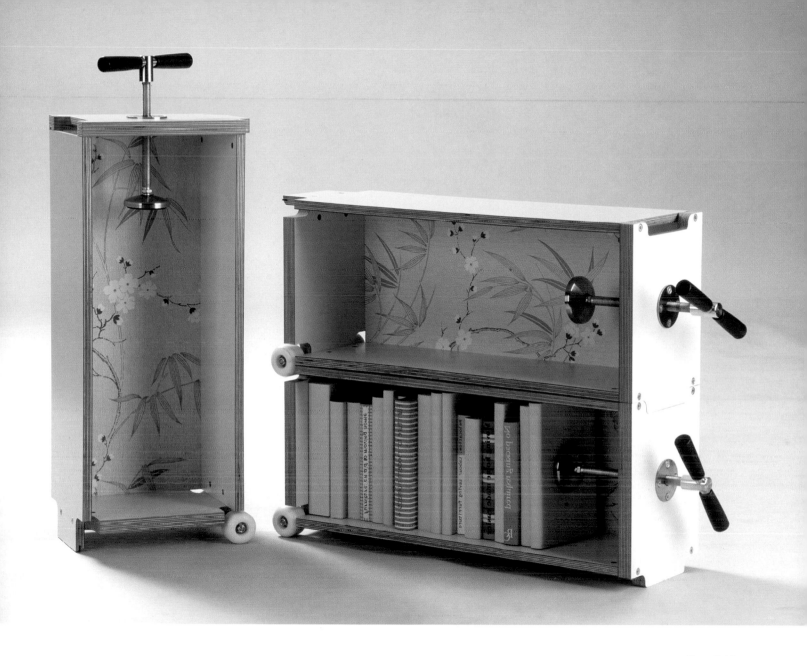

Rose Cobb
Books-to-go

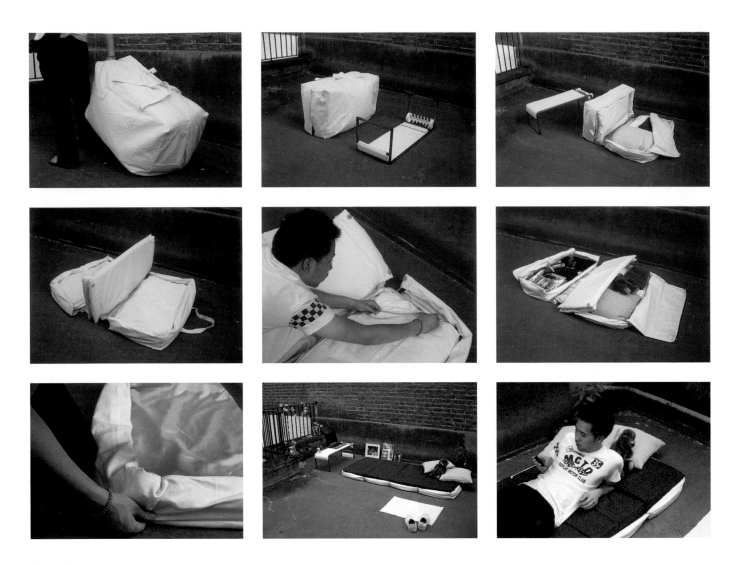

Ditawat Issara
Life

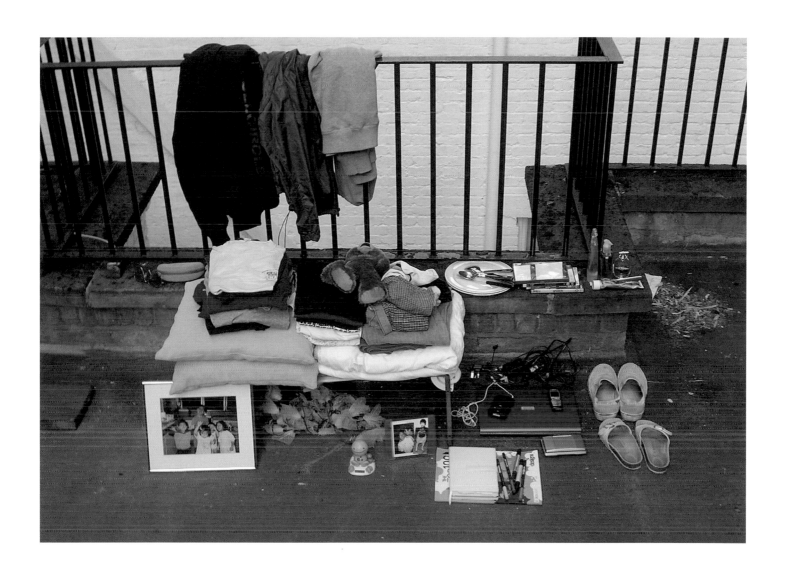

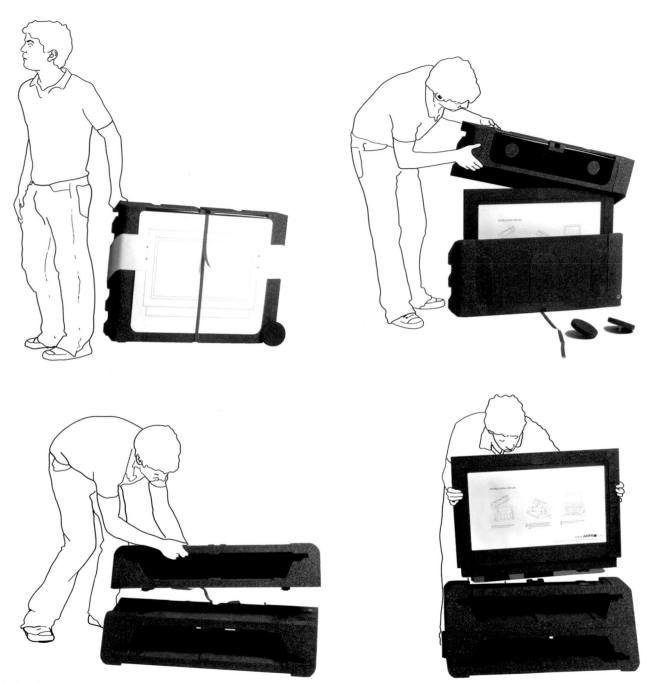

Tom Ballhatchet
TV Packaging Stand

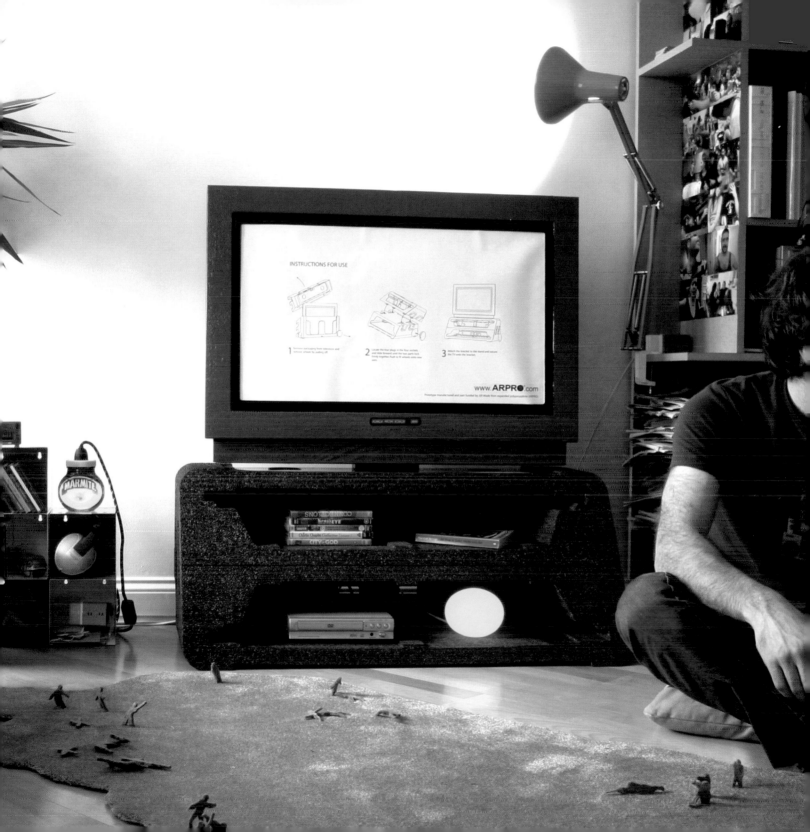

INSTRUCTIONS FOR USE

1 Remove packaging from television and remove wheels by pulling off.

2 Locate the four plugs in the four sockets and slide forward until the two parts lock firmly together. Push in TV wheels onto new unit.

3 Attach the bracket to the stand and secure the TV onto the bracket.

www.ARPRO.com

Stephen Kim
Glom
Photography: Nicholas Zurcher

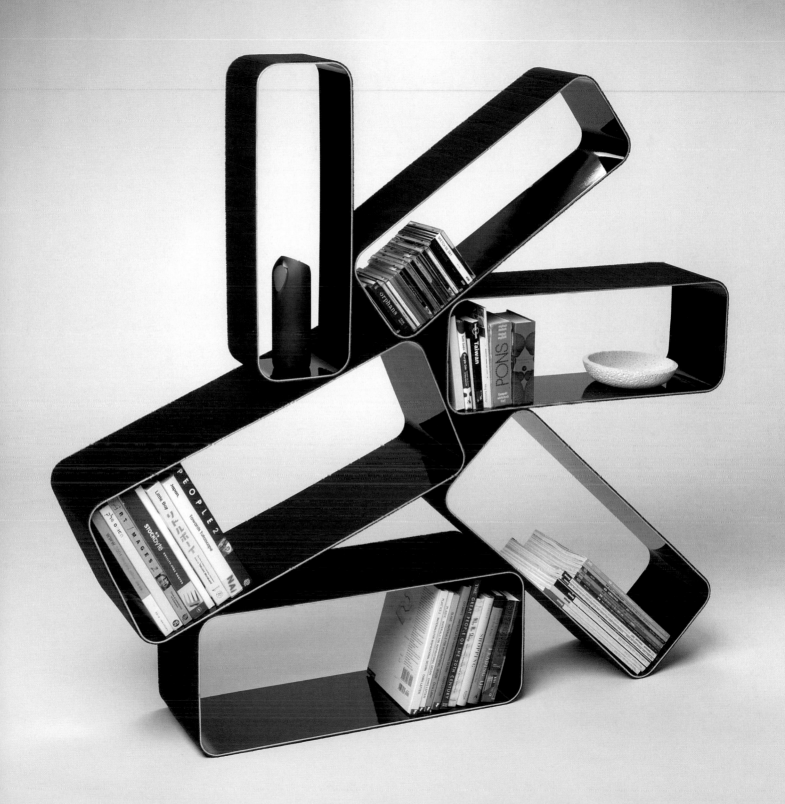

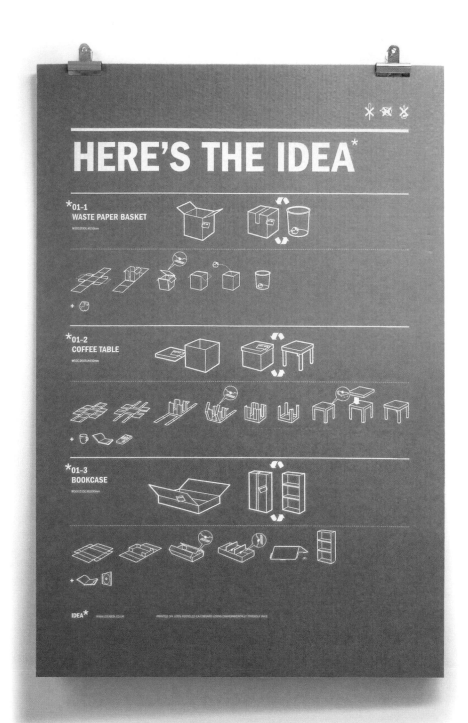

Tim Fraser Brown
Cardboard product poster

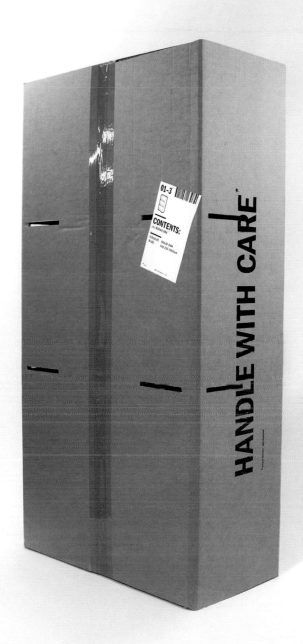
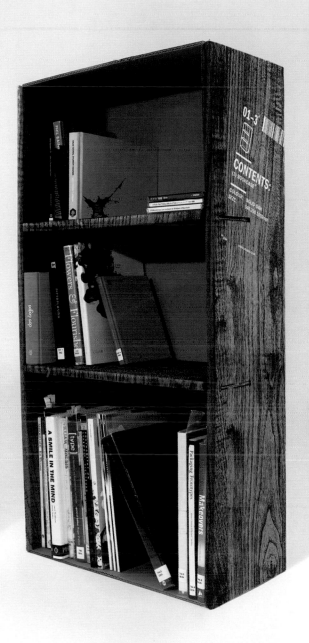

Tim Fraser Brown
Cardboard bookcase

06.

Eccentric Escapism

We are constantly reminded of all that is terrible in life: war on terror, missing children, the credit crunch and global warming. They all feature in our never-ending worldwide negative news feed. Added to that the usual stresses of everyday life, from getting up for work to ensuring a carbon-neutral cup of coffee to the latest celebrity gossip and you would be forgiven if you wished to escape.

The clichés of 'Enjoy it while it lasts' and 'party like there is no tomorrow' probably reflect a very real and human urge to balance our anxieties with pure hedonism. These eccentric escapades are translated into vibrant and overtly surrealistic creativity in a similar vein to that of the Dadaist movement (spawned during another troubled time, peaking between 1916 and 1920). Eclectic inspirations ranging from Pop Art to Alice in Wonderland are merrily mashed up to create a real feast for the eyes. Fashion designers indulge in overwhelming decadence with excessive eating and drinking, while everyone is dressed to impress, going out with a bang in a final and surreal version of 'Fin de siècle' or rather 'début du millénnaire' (start of the millennium).

Designers and artists take on the role of eccentric inventor by exaggerating the mundane tasks of everyday life, coming up with weird 'things to do before you die' creations. Political correctness is replaced with outright silliness and full-frontal surrealism. Notable products include oversized switches to over-perform a mundane task, paper shredders powered by hamsters, and eggs that tip back and forth in place of the balls in a Newton's cradle.

In a world where everything is quantified, qualified, engineered and fine-tuned to perfection, 'Eccentric Escapism' is a breath of fresh air where the weird is wonderful and the unexpected is definitely promoted. Companies able to rediscover the joy and thrill of challenging ideas and offbeat products could tap into this early-adopting niche yet growing market.

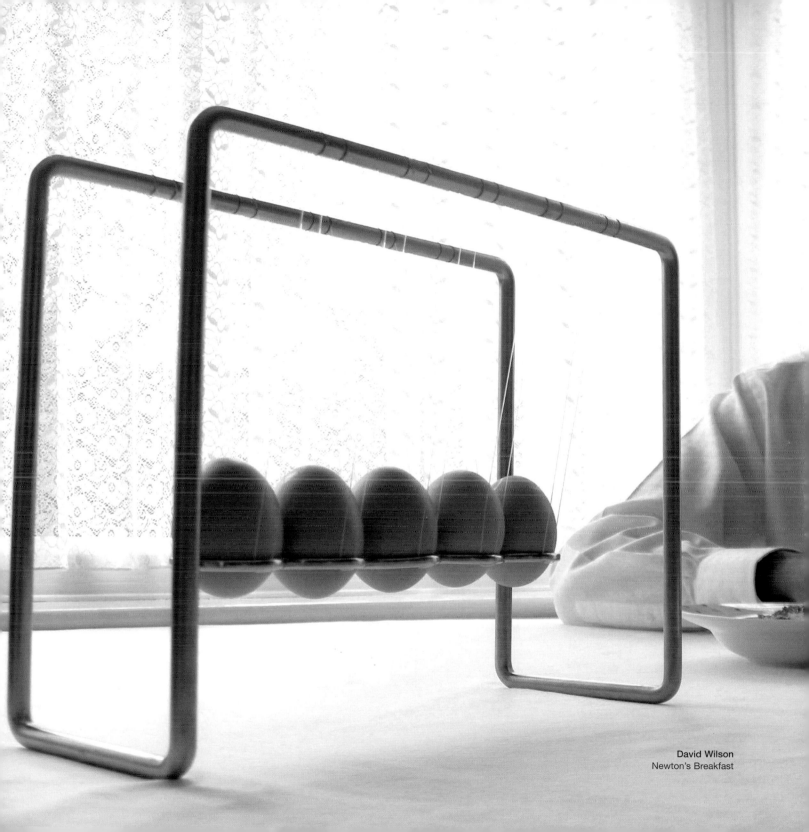

David Wilson
Newton's Breakfast

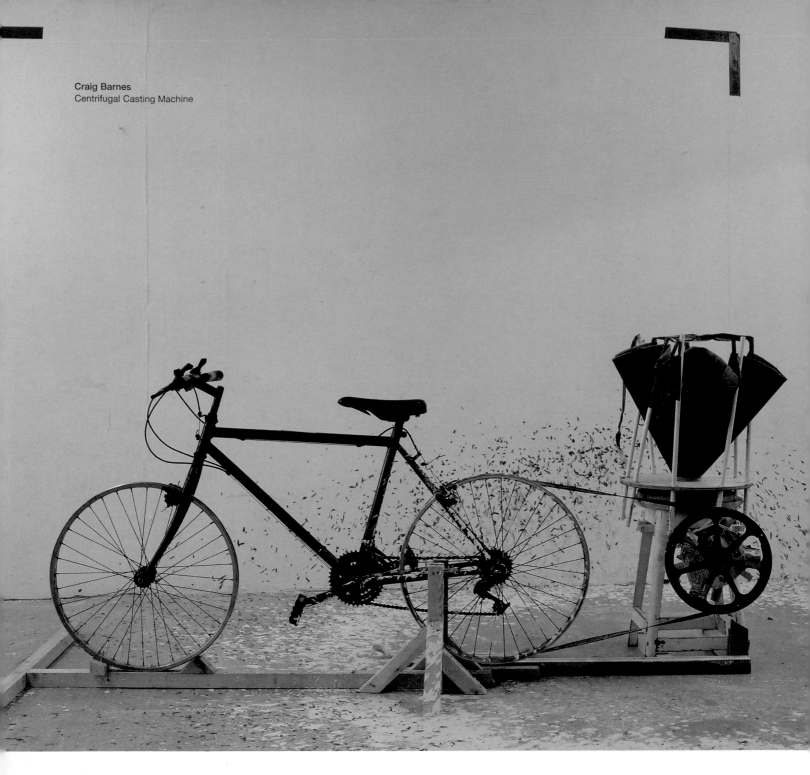

Craig Barnes
Centrifugal Casting Machine

James King
'It's Alive!'
Symbolising eccentric invention

Isabelle Webster
Pen Tipper Turner Viewer

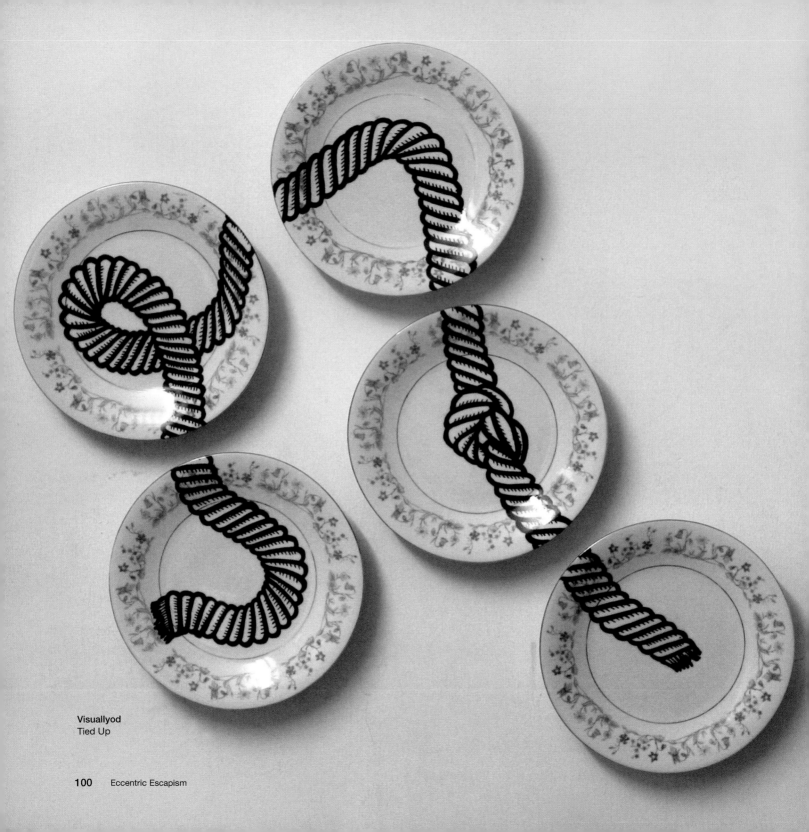

Visuallyod
Tied Up

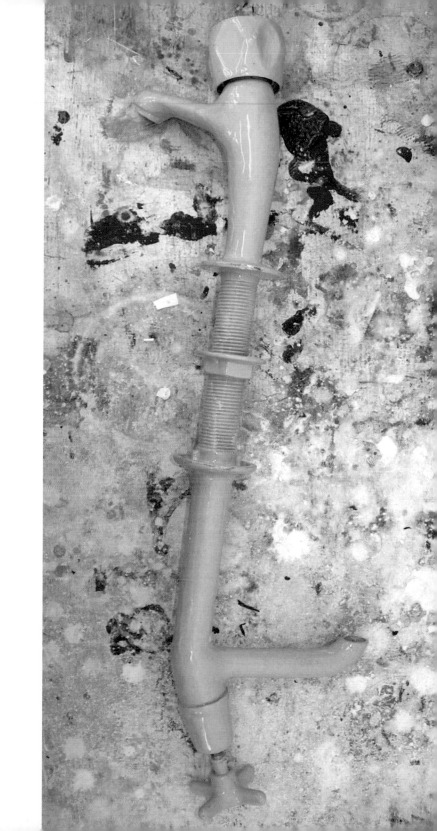

Lozan Ghafoor
Taps (Yellow)

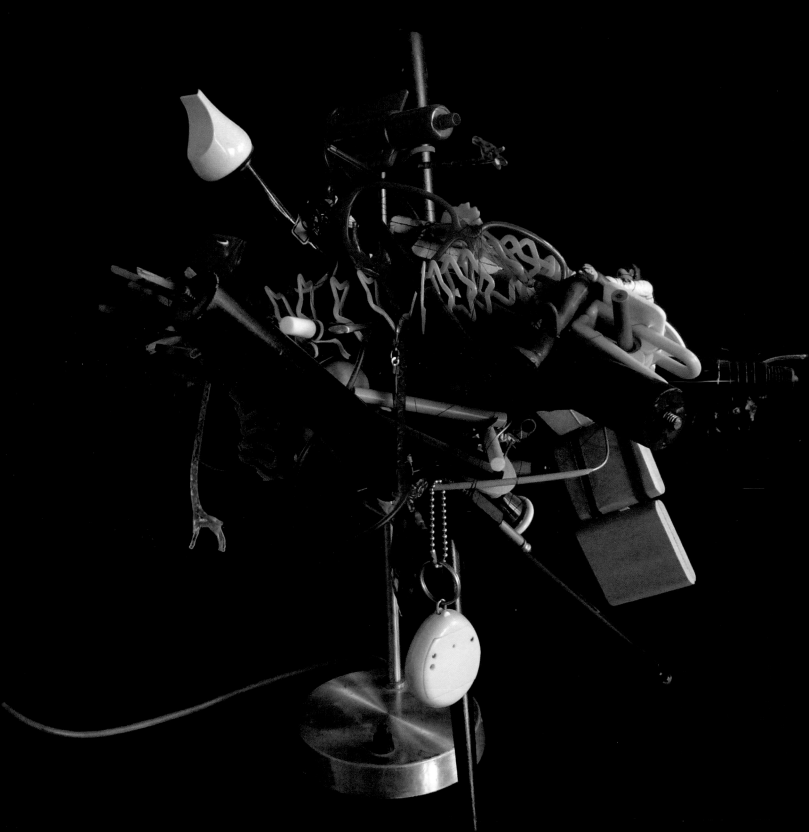

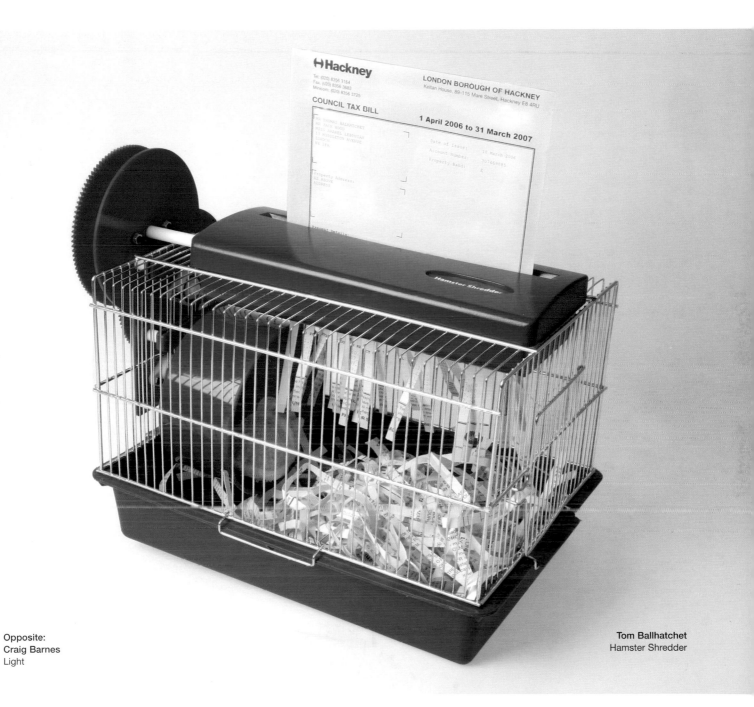

Opposite:
Craig Barnes
Light

Tom Ballhatchet
Hamster Shredder

Opposite:
Leonid Alexeev
Untitled
Photography: Philip James

Theodor Anastasato
General Viagra

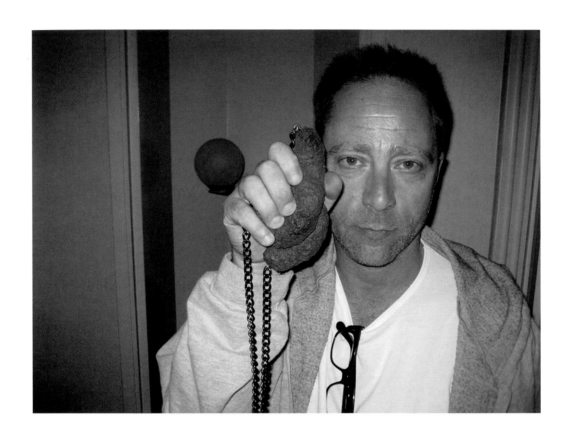

Theodor Anastasato
The Wholesome Waste Necklace

Theodor Anastasato
Intellectual Leisure

Marie Kristiansen
Here They Are: Portraits of the Female Masquerade
Costume Design: Edeline Lee

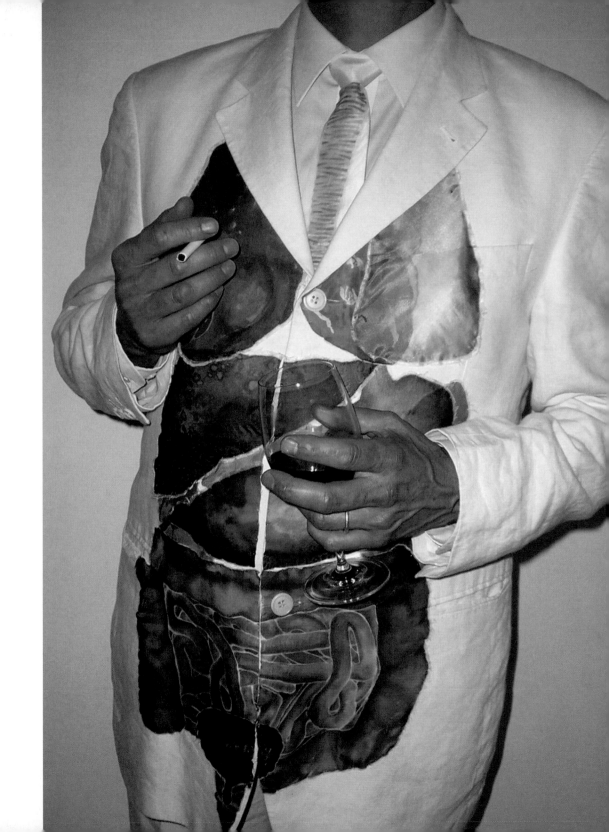

Caroline Gates
Death Suit (right)
Knitted Organs (opposite)

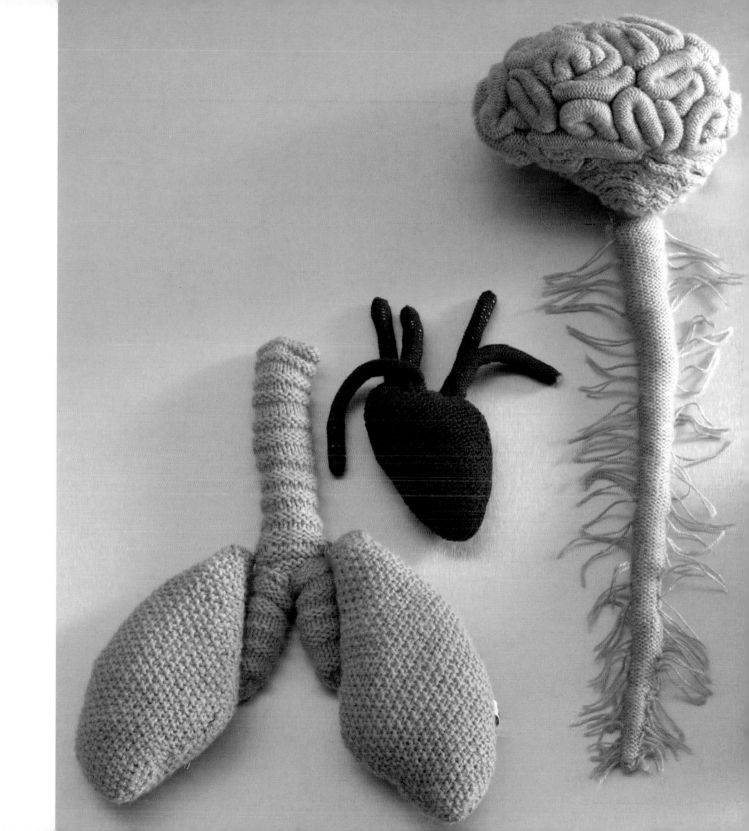

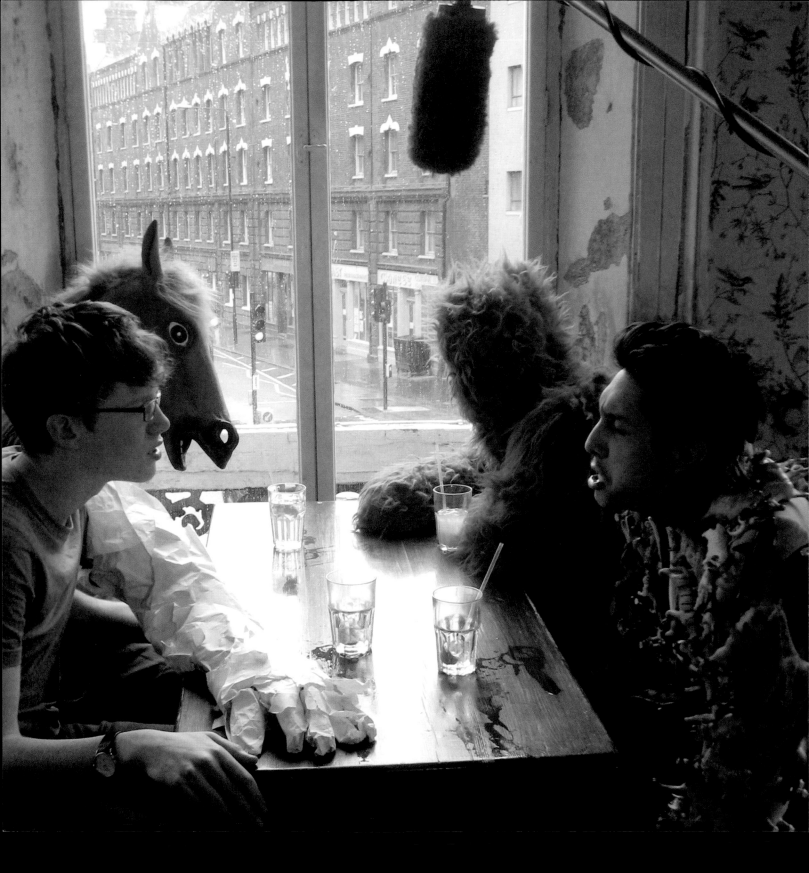

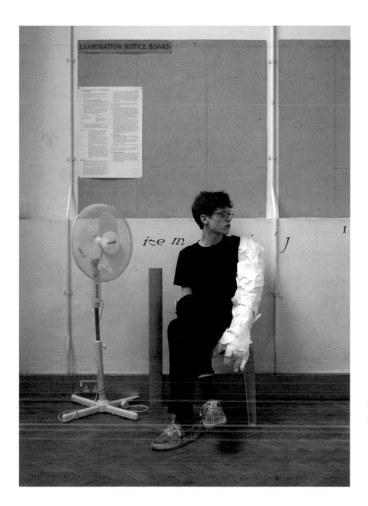

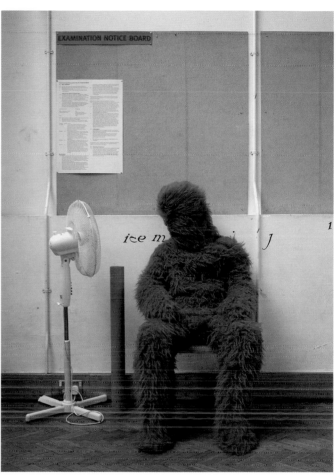

Jean Jullien
Filming (opposite)
Normality Issue Posters (above)

07.

Geometric Trip

After the recent over-use and abuse of 'New Rave' and late-1980s day-glo graphics and fashion styling, designers are moving towards a more intelligent and considered revival of the early to mid-1990s techno movement. It is mixed with a resurgent 1960s-inspired Op Art, producing repetitive geometric patterns. In a similar vein to the De Stijl and Minimalist movements, it seeks order through the abstraction of stripped-back essential forms and shapes. This type of work is created under a considered and precise work ethic, with a constructive mindset that is focused on visual style. There are a host of designers and artists producing work with mesmerising visual results, akin to the kaleidoscopic, psychedelic abstract patterns of the earlier swinging decade. Much of the work by these artists resembles magic-eye pictures; they not only produce slight optical effects but they are also stringently focused and accurately constructed.

Gone are the swirling vector graphics and smooth colour gradients. The trend is split down the middle between synthetic and analogue methods. Making use of numerous computer programs to produce perfect precision, digital designers harness a wide range of technologies and editing software to produce familiar shapes but with new forms and strange effects. Graphic designers hark back to retro computer-game graphics and early CAD visual language; fragments of bold colours complement pixelated and blocky imagery. Photo trickery turns the contents of an empty pint glass into a mass of black and white polka dots. In contrast, the time-consuming handcrafted pieces are even harder to take in, with their intricate details made with a meticulous and extremely patient approach. It could be argued that this trend is as much about the process as it is about the final result. The work may often seem all too familiar at first glance, but it is the details and the finishes that make the work so intriguing. For instance, we marvel at the work made with hundreds of painted matchsticks and a honeycomb of woven fabric layers.

This trend sees a tight balance between geometric mathematical minimalism and daring hues. As bold colours complement the simple shapes, striking illusions and abstract formations are created. The pairing of some colours produces hypnotic effects and optical illusions, while other pieces have pared-down essential shapes and angles in pure whites and neutral tones. Layers of folded paper are employed to diffuse light, creating sharp angles with subtle white and grey tones.

This visual trend is not solely centred on graphics, but feeds into textile and fashion design. There is room for other disciplines to be immersed in the geometric trend – not just the aesthetics, but the process and the methodical mindset can be carried into three-dimensional design, modular products and geometric architecture.

Right: Letty Fox
Untitled

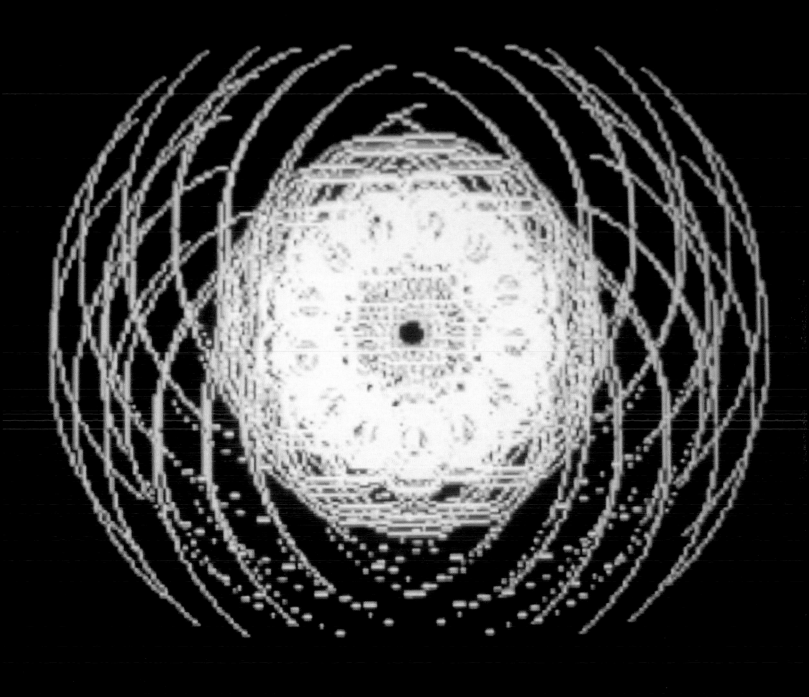

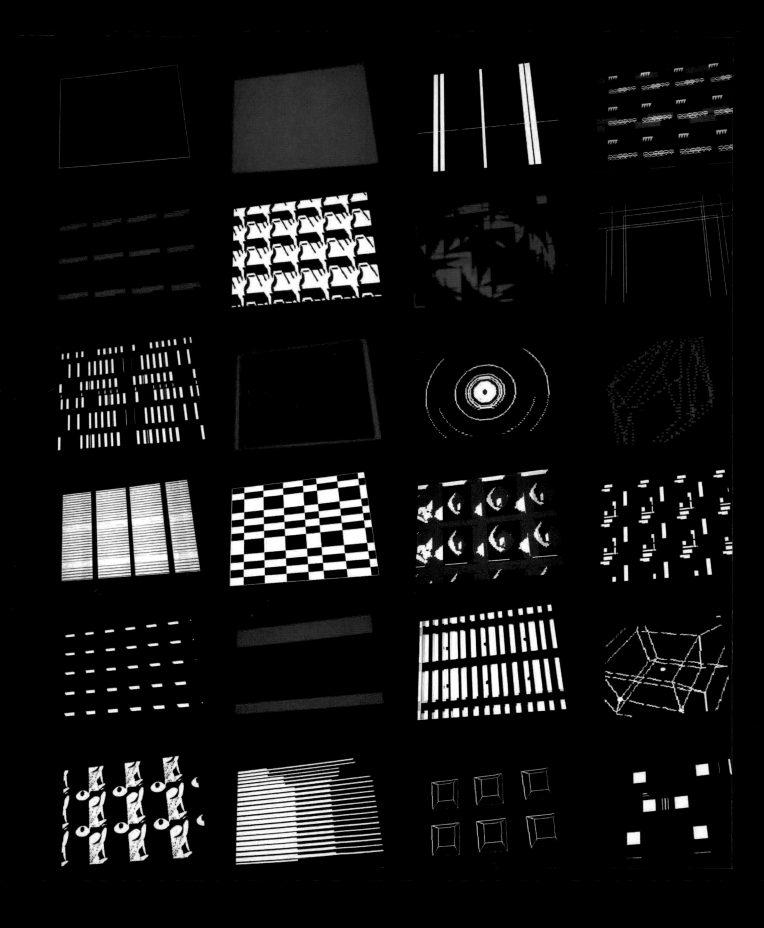

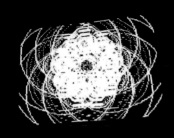

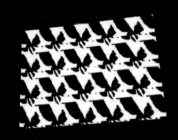

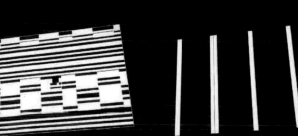

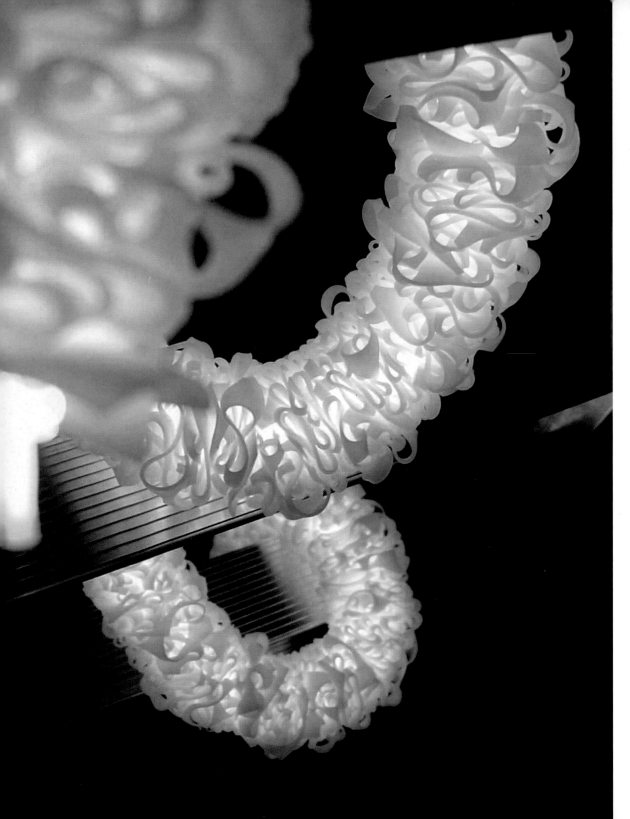

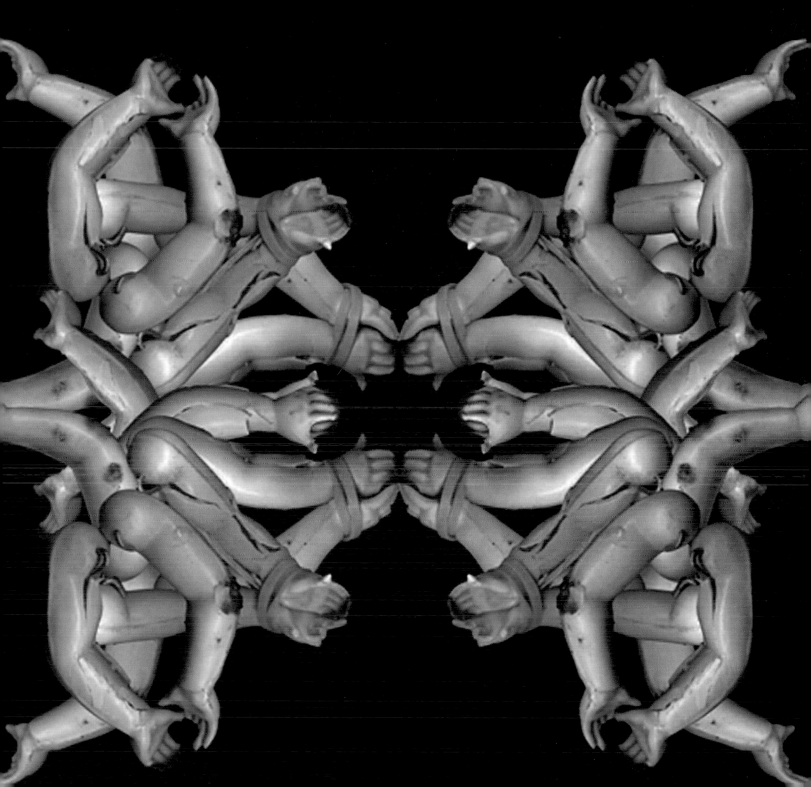

Masayoshi Fujikawa
Untitled, 2007

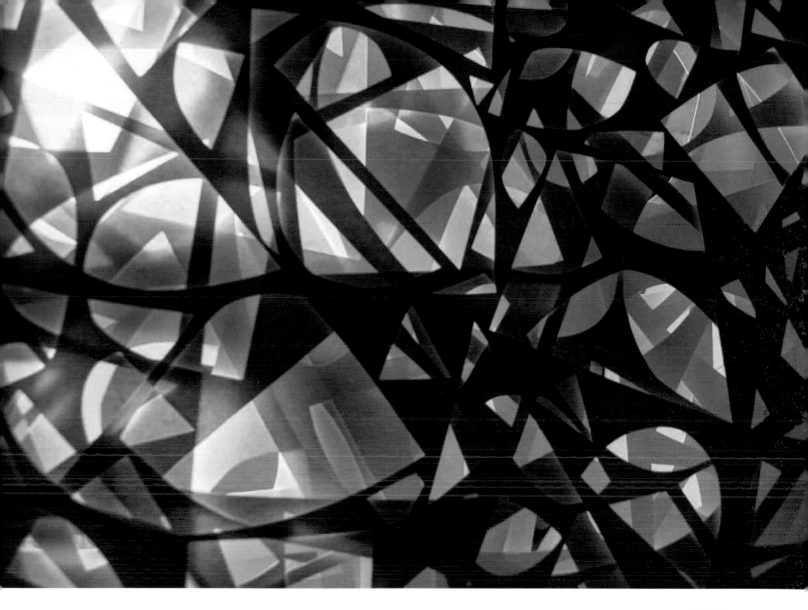

Katie Bean
Untitled
(Layered paper cuts)

Next page:
Sofie Brünner
Metal Ikat (left)
Honeycomb (right)

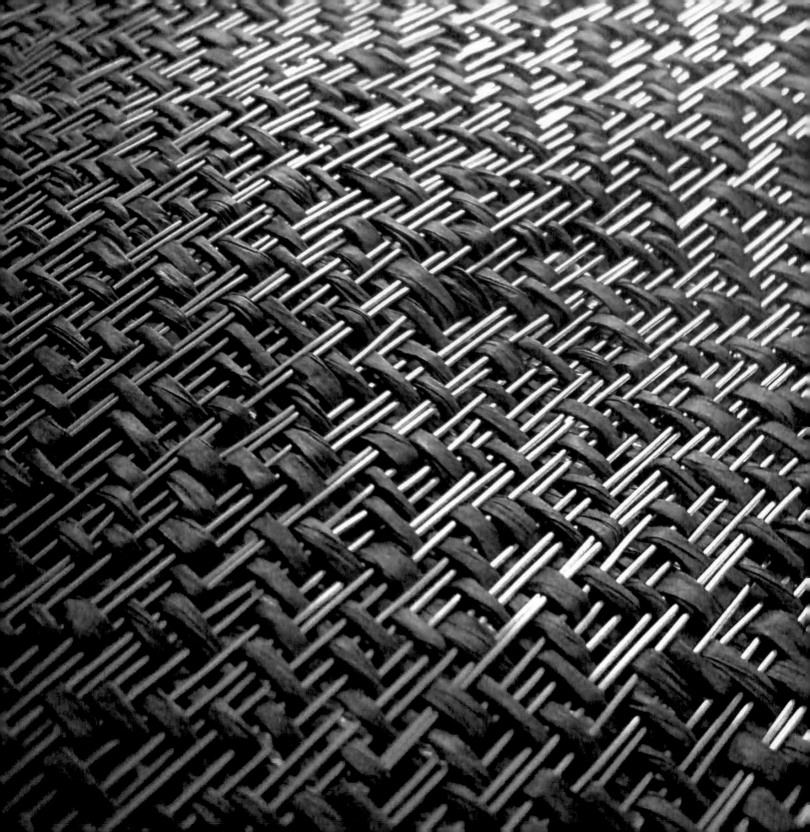

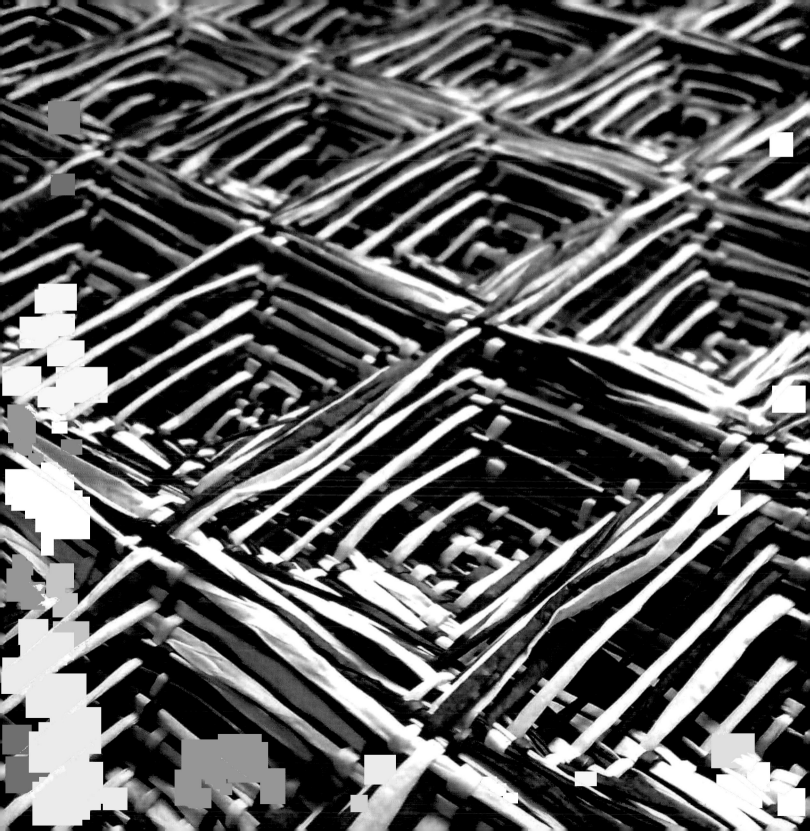

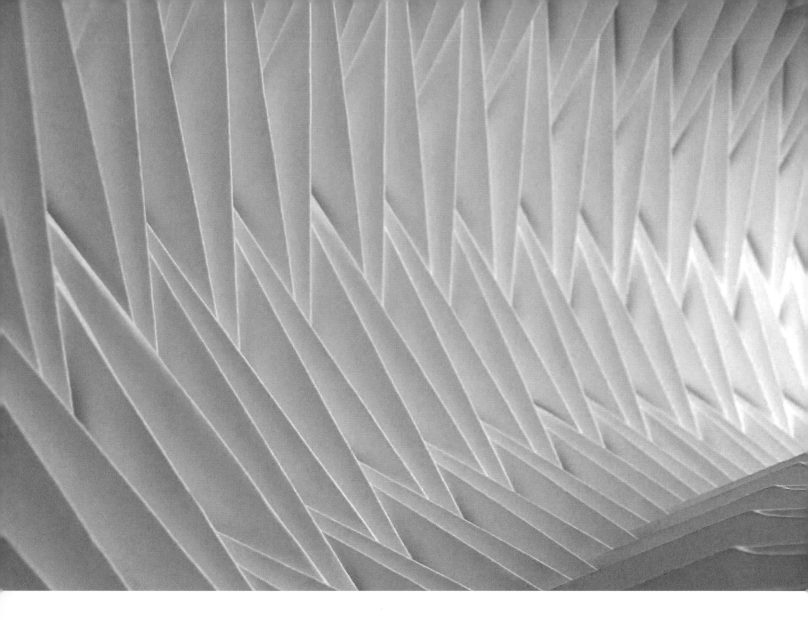

Richard Sweeney
Paper Pleat, 2007
Pleated 220gsm paper

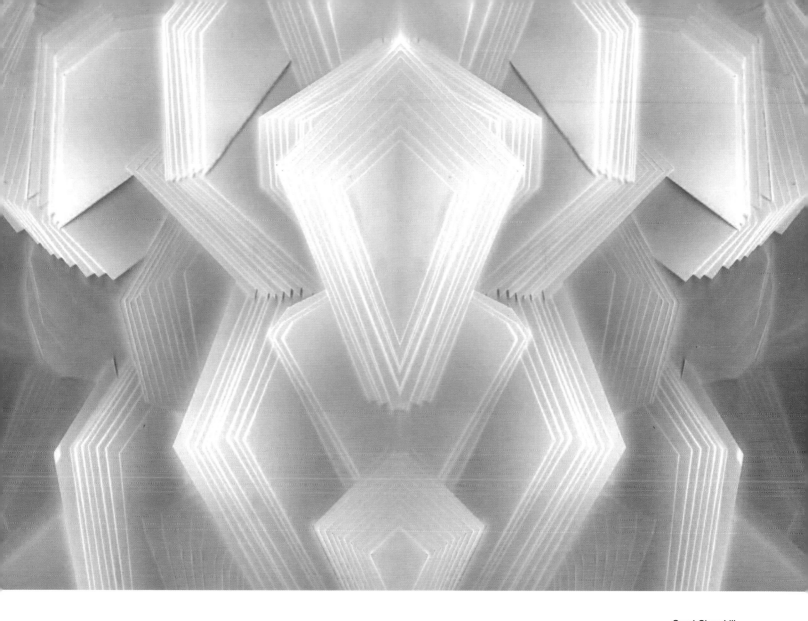

Coral Churchill
Papercut Mandala

Next page:
Masayoshi Fujikawa
Untitled, 2007

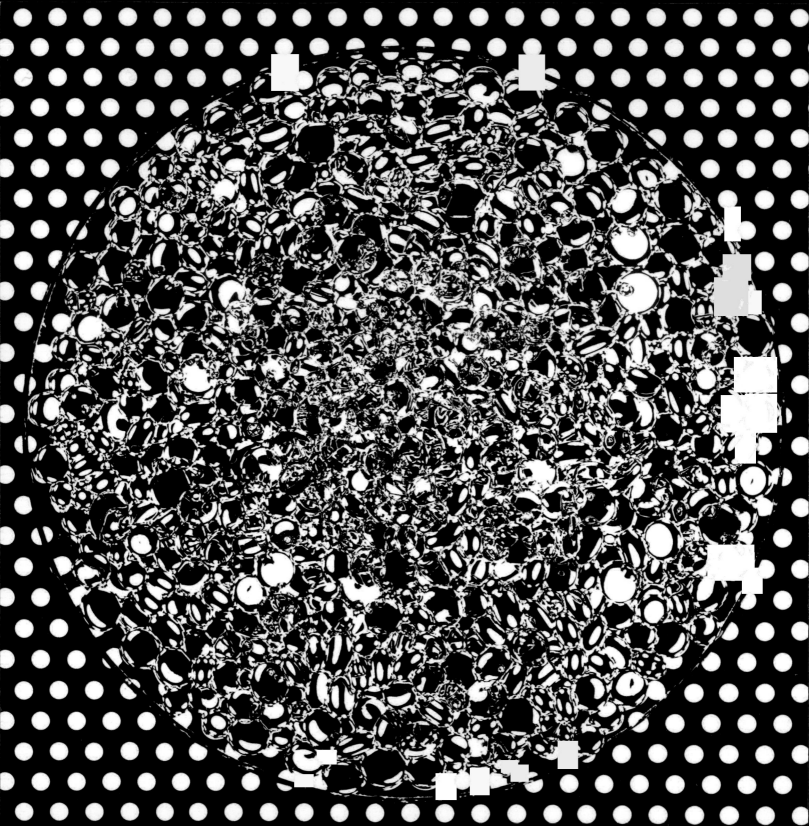

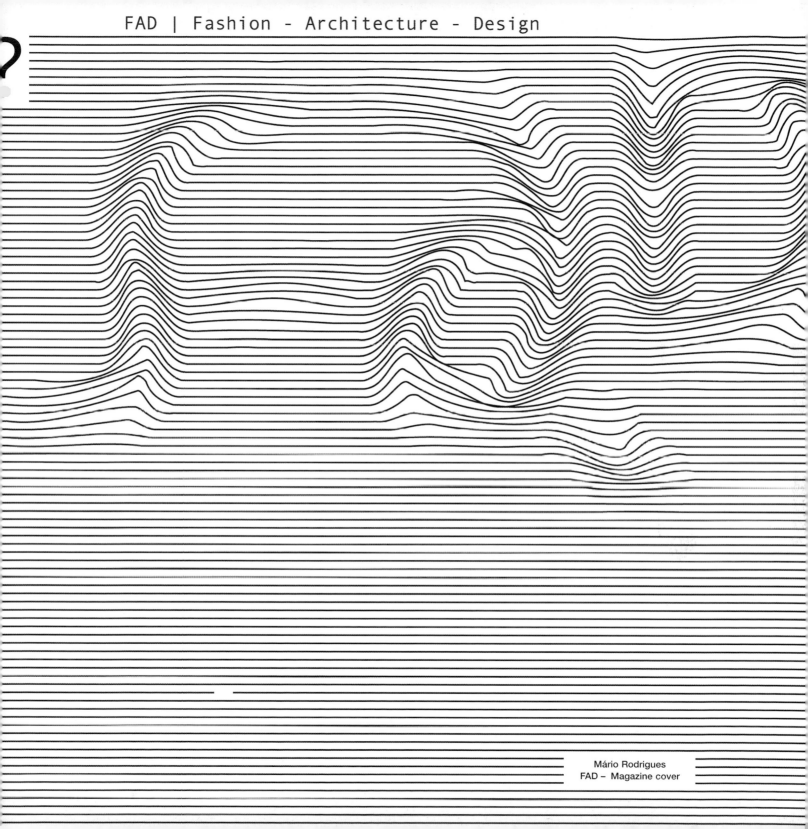

Mário Rodrigues
FAD – Magazine cover

Maria Eisel
Virtual Cloth

Maria Eisel
Virtual Cloth
(Red)

08.

New Tradition

Is the web 2.0 generation just lazy? Reports in recent years have argued that exams have become too easy, and internet life, including keeping in touch with friends, has made life's daily activities increasingly effortless. The image of the 'one click away from anything', TV-obsessed, couch-potato teenager living at home is well established. As a consequence, life increasingly becomes more sedentary. But the youth of today have grown restless with a need to do something tangible. Their first natural reaction is to take matters into their own hands and create online platforms for self-publishing. The second and emerging step is to actually rediscover how to actively design, make and produce physical objects.

Designers, illustrators, jewellers and artists have recently been evolving into a new breed of craftsperson. Fascinated by what the world was like before the omnipresent digital realm even existed, many designers have been breaking free to rediscover traditional practices by mixing the old and the new, making things by hand rather than with a mouse. Traditional manufacturing methods are being revisited and updated, side by side with experimental material approaches and the merging of visual languages. Designers plunge into historical references and mix up traditional ideas, etiquette and rituals. A move away from mass production means quality and technique can again take centre stage in this new focus on process.

This new movement is more than just pinching styles from times gone by, and gives a new lease of life to old objects. Creatives are experimenting with basic processes, using their bare hands to develop products that are as attractive to look at as they are to make.

This trend is also about preserving the old. Doilies are given a revamp; ashtrays (a fast-dying breed) are transformed into candles while retaining their iconic design features. Designers revisit old and lost traditions from high to low art, from intricate ornaments to kitsch oil paintings. Some designers play with the still-life painting genre, photographing plastic toy fruit instead. Other old-fashioned artefacts are given a new lease of life: a classic pocket watch is digitized and a fan is transformed into a mini solar charger.

Consumers are increasingly demanding tailored products in a world where monotonous ready-made, mass-produced and generic goods line the shelves. Many independent designers, retailers and manufacturers have been quick to put forward limited edition art, products and clothing, swiftly followed by larger corporations utilizing artist collaborations and brand tie-ins produced in limited quantities in a bid to offer some kind of uniqueness. But some consumers are cynical about what they consider disingenuous 'mass customization' and still feel unfulfilled with a desire to own or create something truly unique and bespoke.

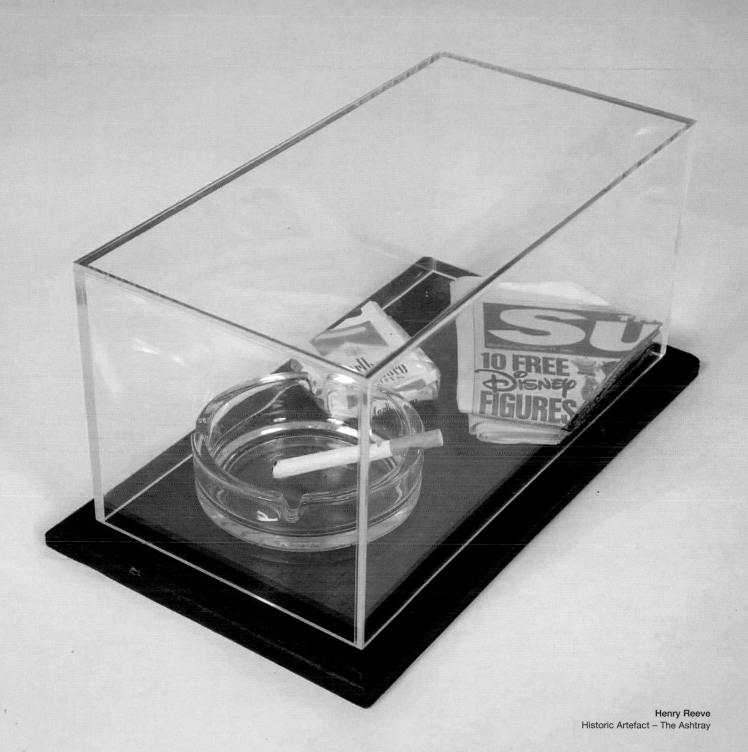

Henry Reeve
Historic Artefact – The Ashtray

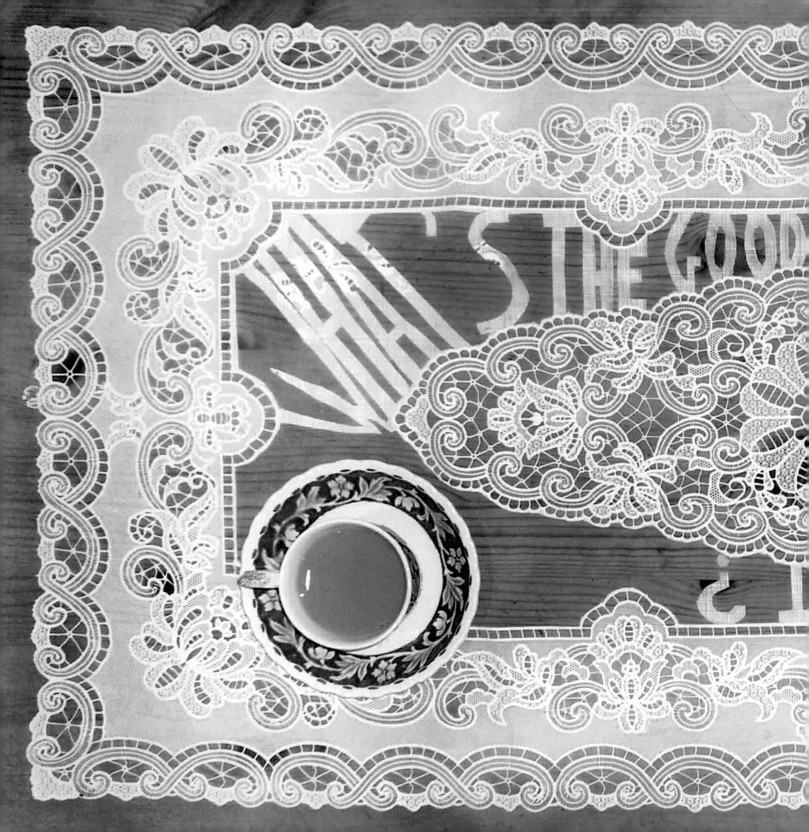

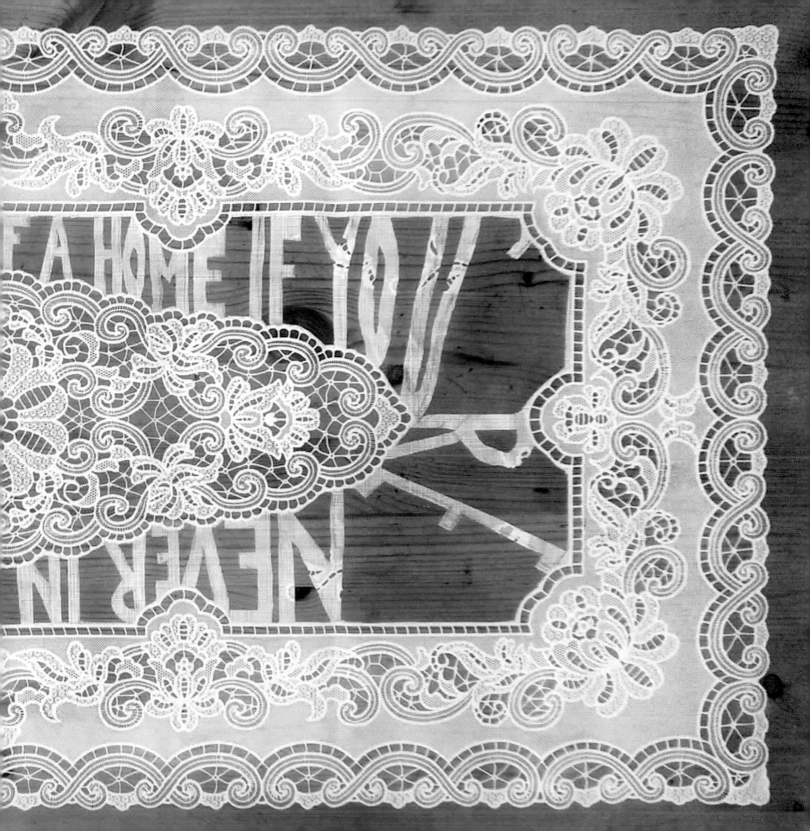

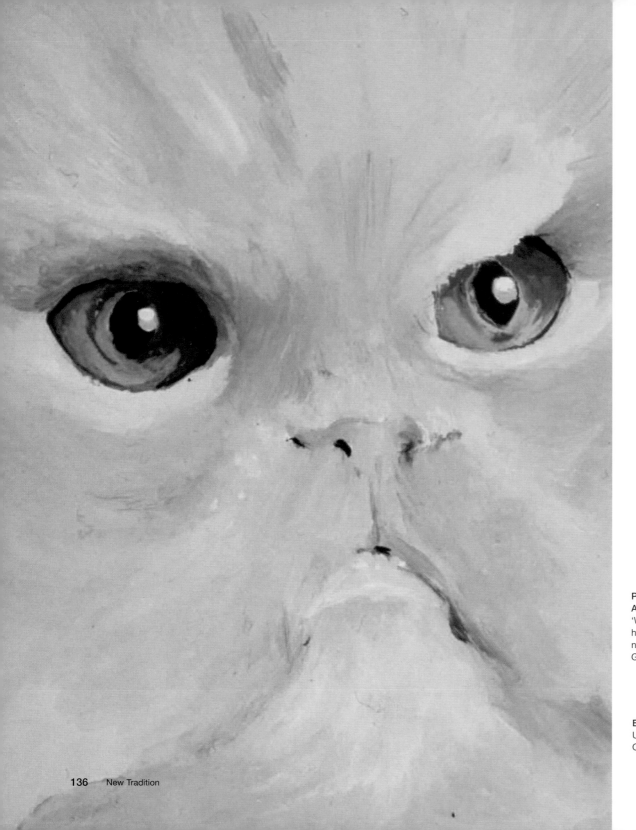

Previous page:
Arianna Osti
'What's the good of a
home if you are
never in it?'
George Grossmith

Emma Puntis
Untitled, 2006
Oil on board

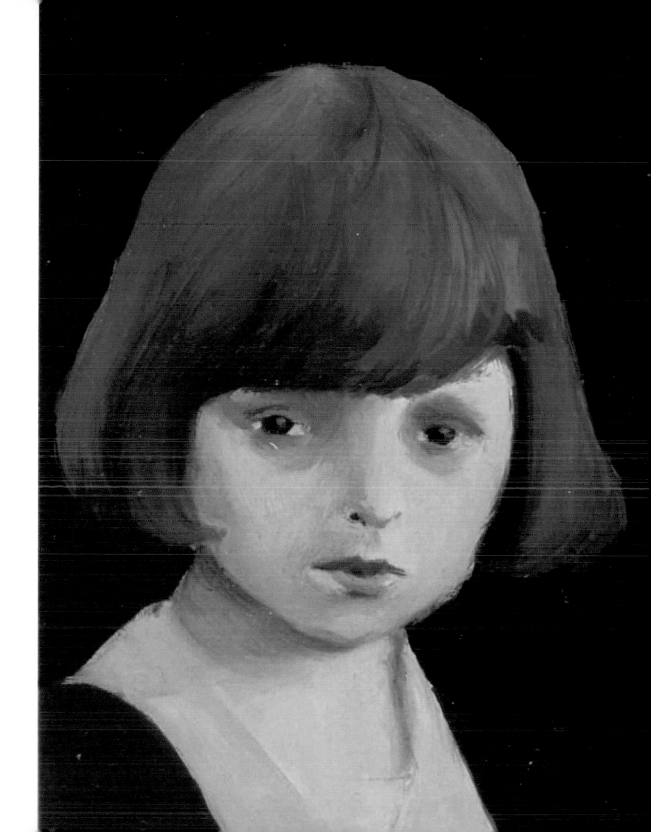

Emma Puntis
Untitled, 2007
Oil on board

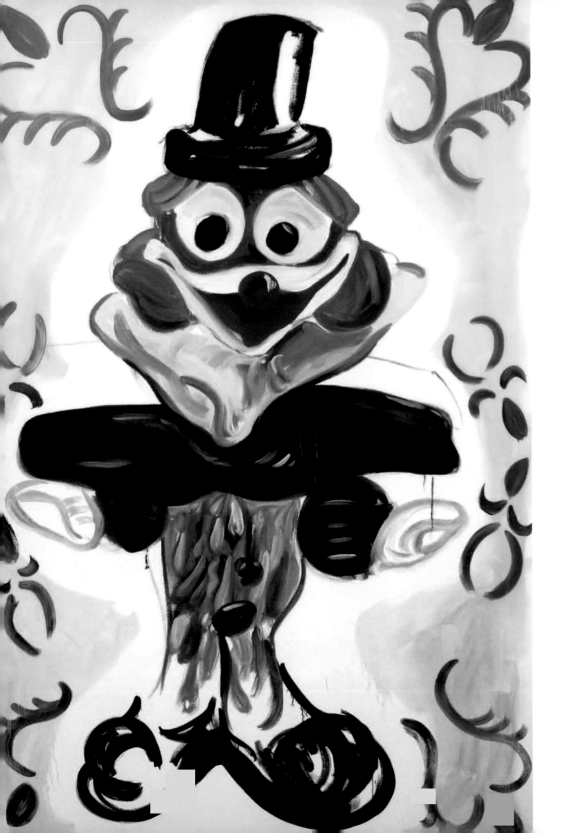

Alli Sharma
Gary, 2007
Oil on canvas

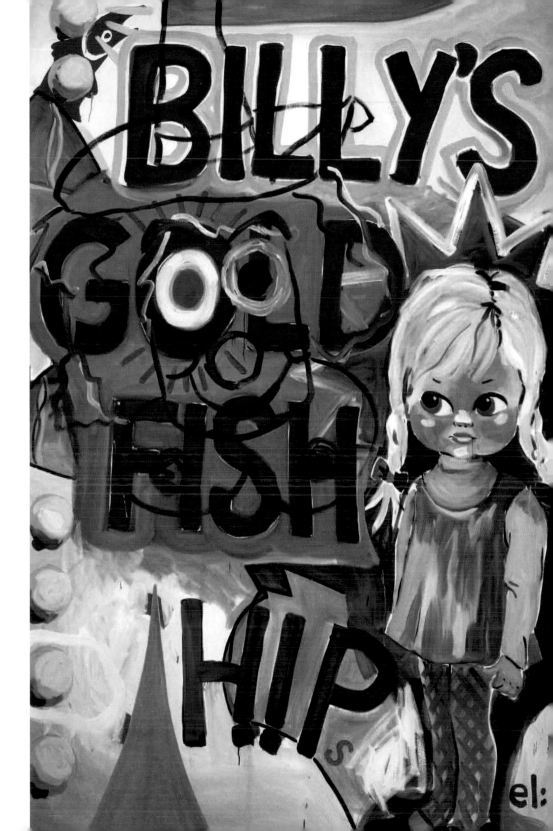

Alli Sharma
Billy's Gold Fish Hips, 2007
Oil on canvas

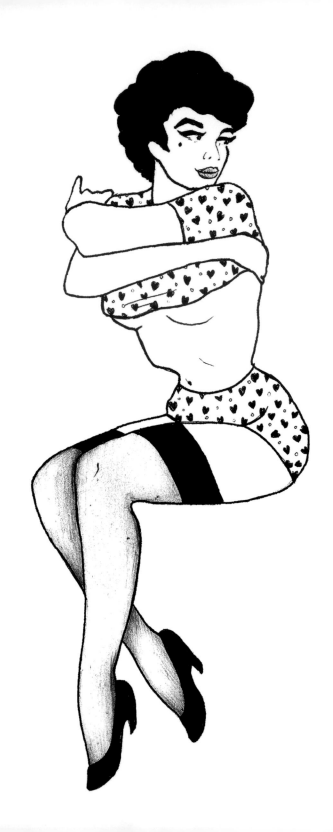

Felicity Marshall
Pin-Up!

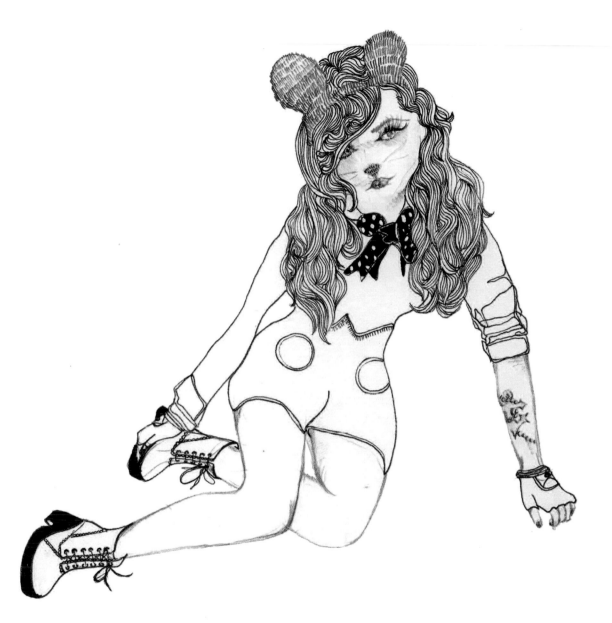

Hayley Friel
Mouse Lady

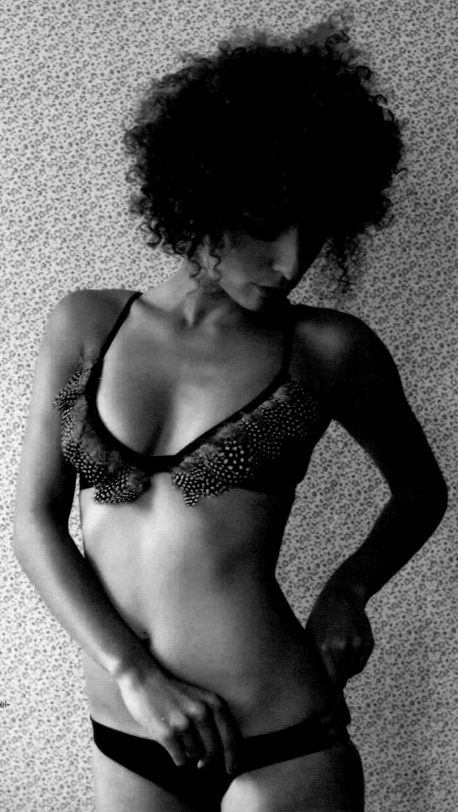

Ninette Van Kamp
Souffrez Pour Moi; Bejewelled (jewel-encrusted bra and knickers)
Photography: Isabelle Schönholzer

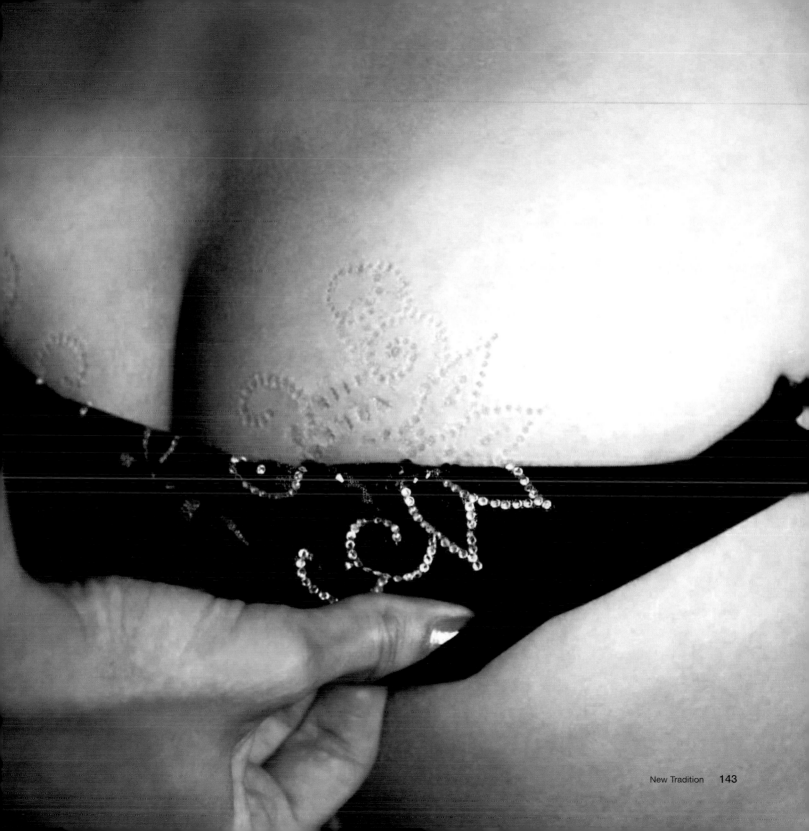

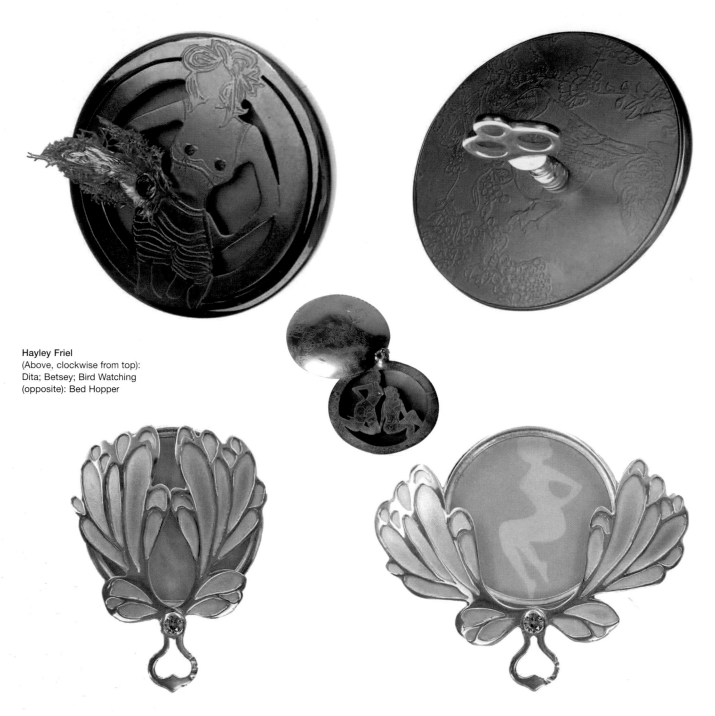

Hayley Friel
(Above, clockwise from top):
Dita; Betsey; Bird Watching
(opposite): Bed Hopper

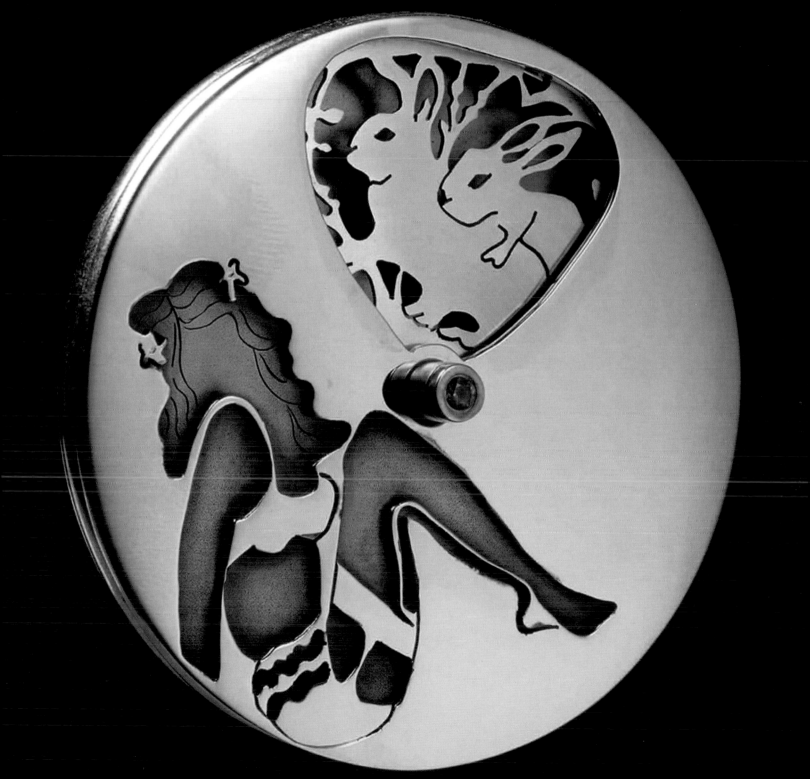

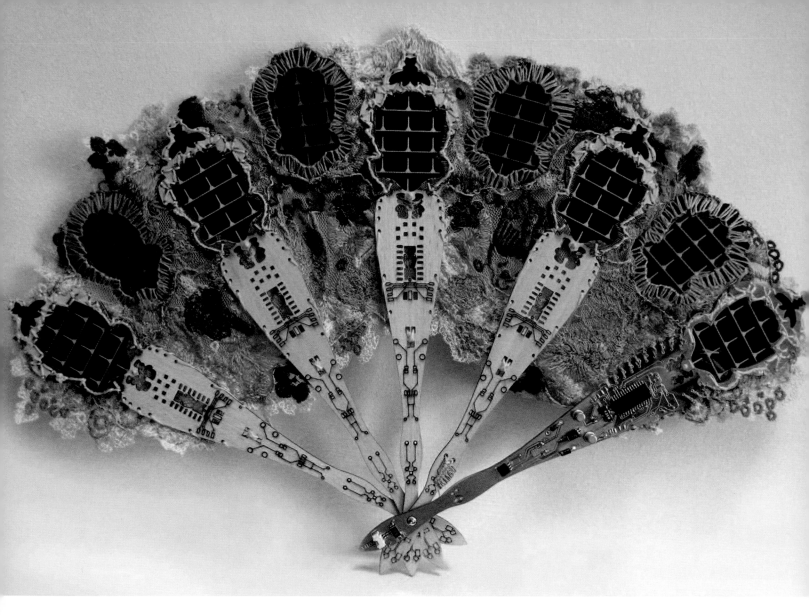

Elena Corchero
Solar Vintage Fan

Page 148:
Oscar Bauer and Ewan Robertson
Still Life, 2007

Page 149:
Henry Reeve
Wax Ashtray

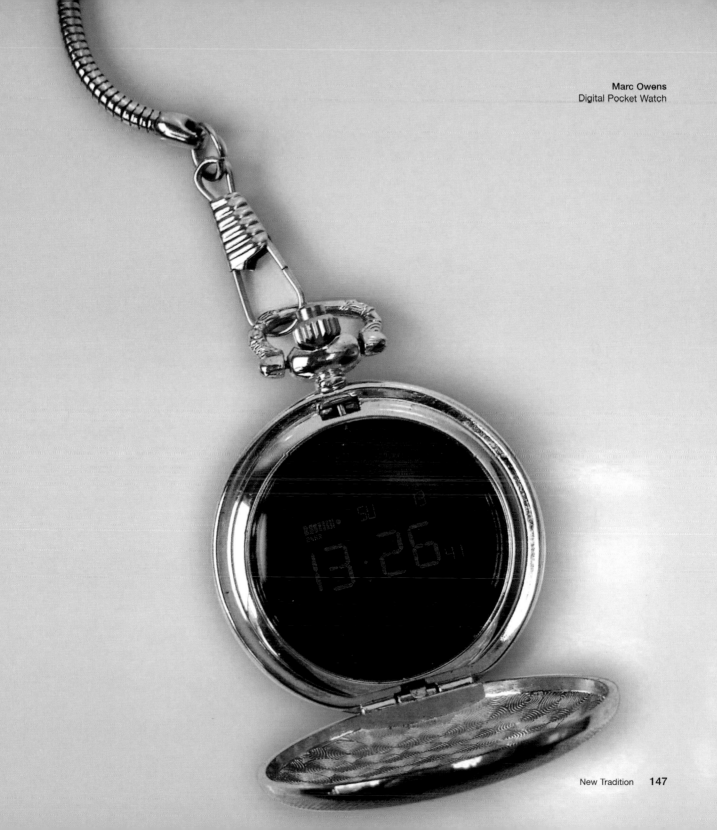

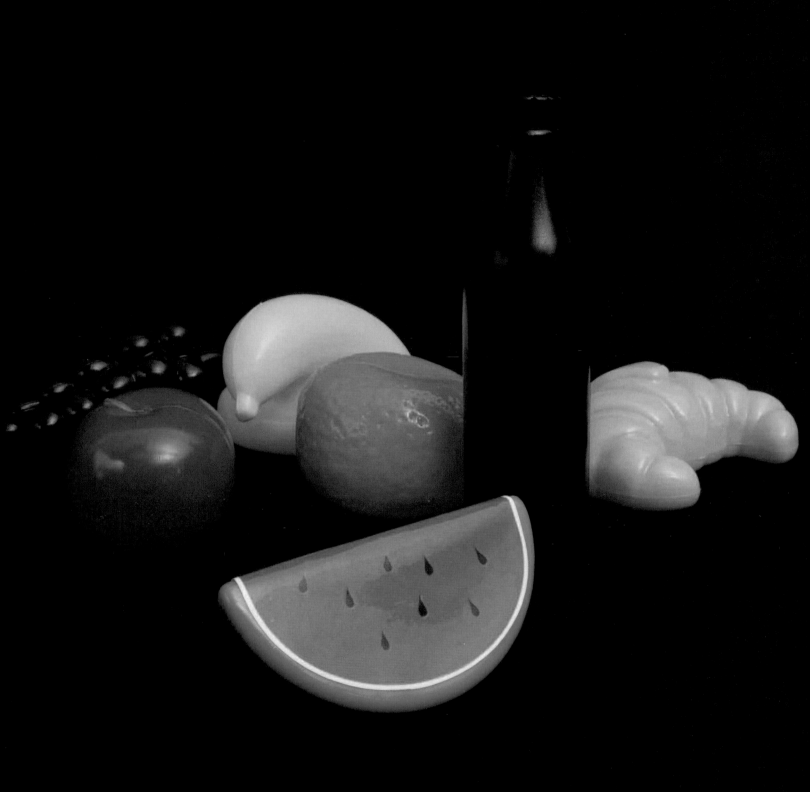

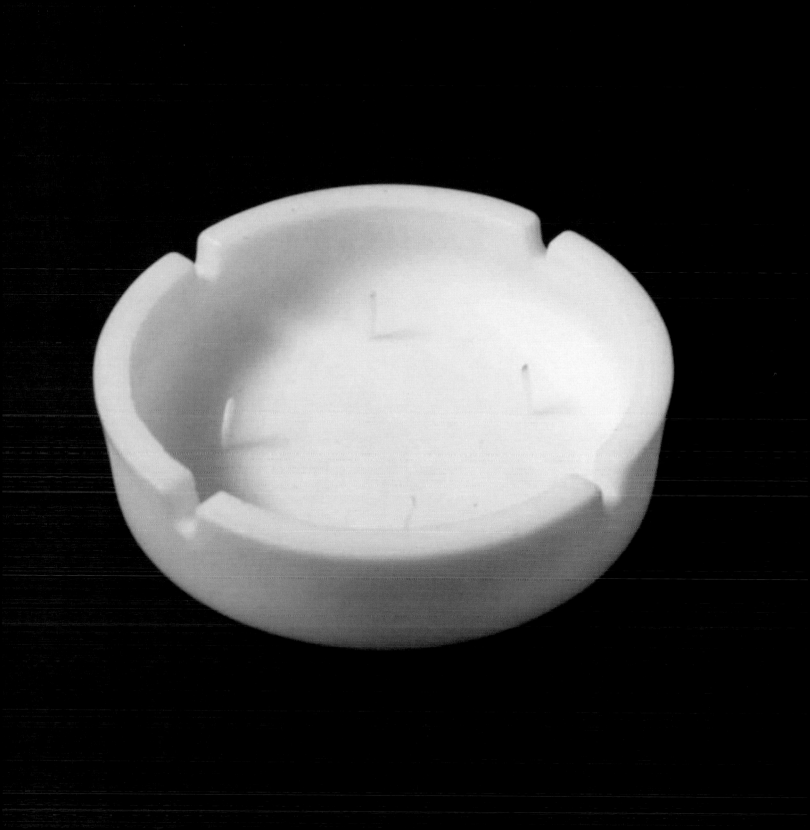

09.

Urban Canvas

Today, half of the world's population lives in cities, compared to 1900 when only one in ten resided in an urban area. This urban-living trend is set to grow with mind-boggling projections: in 2015 Tokyo will be home to more than 35 million inhabitants, 21 million will reside in Mexico City and the same in Bombay, while São Paulo and New York will each be home to 20 million.

The relentless growth in urban population is generating a constant supply of fresh city-centric ideas and energies. The countryside is slowly emptying itself of youth, attracted by the cities and their opportunities. This boom in new arrivals is delivering a mass of creative energy ready to fill the urban canvas.

Graphic designers and artists capture one of the age-old struggles in urban landscapes: green spaces battling against ever-higher skyscrapers and an all-encompassing concrete sprawl. While some regard the future of urban living as something raw and terrifying, others simply embrace the inevitable by celebrating cities in all their hard-edged glory.

The recent green imperative has strengthened the hand of those seeking to claw back some of the greenery in the city. They are armed to the teeth with trowels, shovels and the necessary urban camouflage to help nature claim back the city. This conflict between bold urbanism and flourishing environmentalism is reflected in an emerging art trend.

During the night, after-dark city dwellers creep through the streets planting flowers and preening bushes in plots of urban wasteland. Students with no access to gardens or parks swarm through the inner-city estates in a bid to construct synthetic nature in places where nothing will grow. These deeds try to build a sense of community not only between those taking part, but with all those who walk through the transformed urban landscape.

On real canvas, artists depict scenes of weeds and vines overrunning concrete playgrounds, while green graffiti artists fight back with their green fingers in a battle for survival. 'Urban Canvas' demonstrates how art and design can be used to comment not only on the state of urban living, but also how actively altering our surroundings can stimulate change. City authorities around the world are initiating a slow yet profound change in the perception of what constitutes a positive urban environment.

Richard Reynolds
finds time for some guerilla gardening in
Brixton on his way to a DJing gig.
Street Life

Opposite:
Chris May
Trodden, 2007
Oil on canvas

Chris May
Untitled, 2007
Oil on canvas

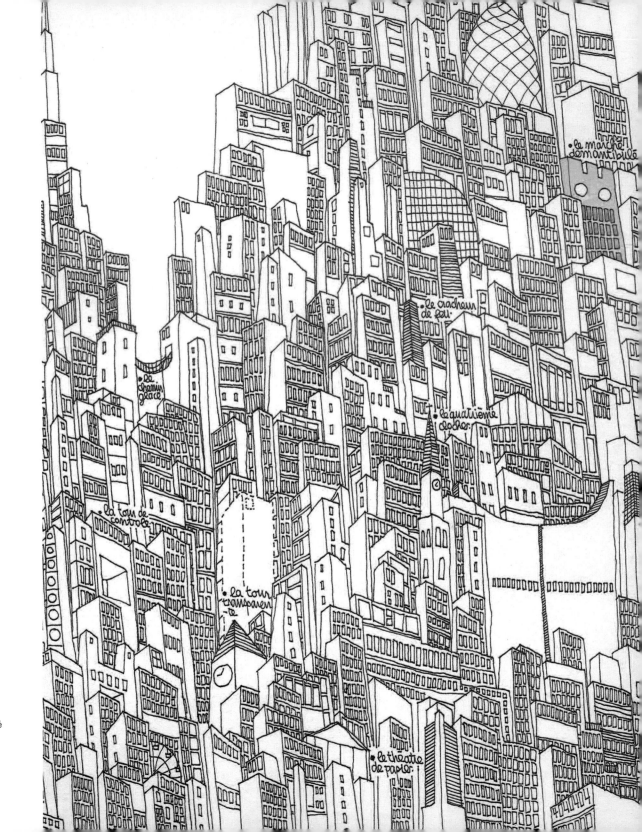

Thibaud Hérem
Le Marché demantibulé

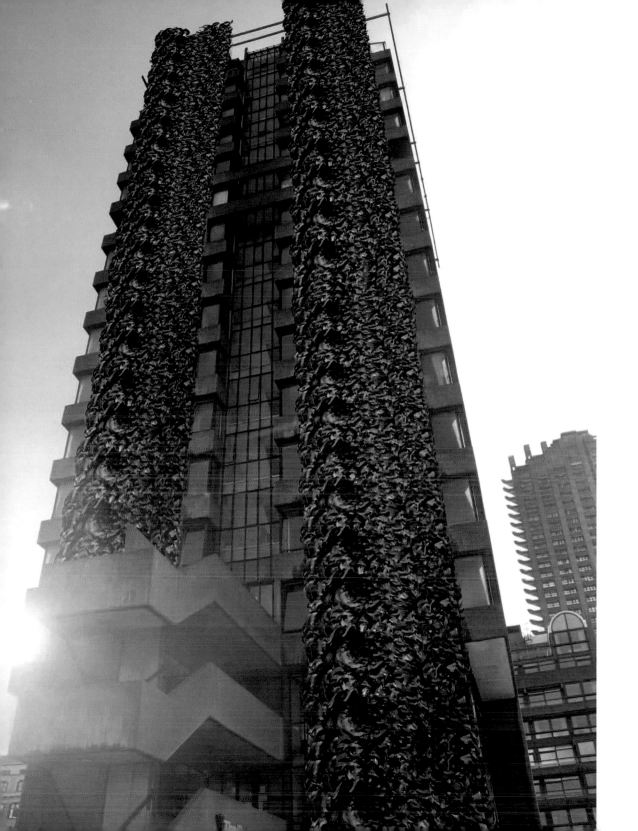

Seetal Solanki
Urban Fabrication

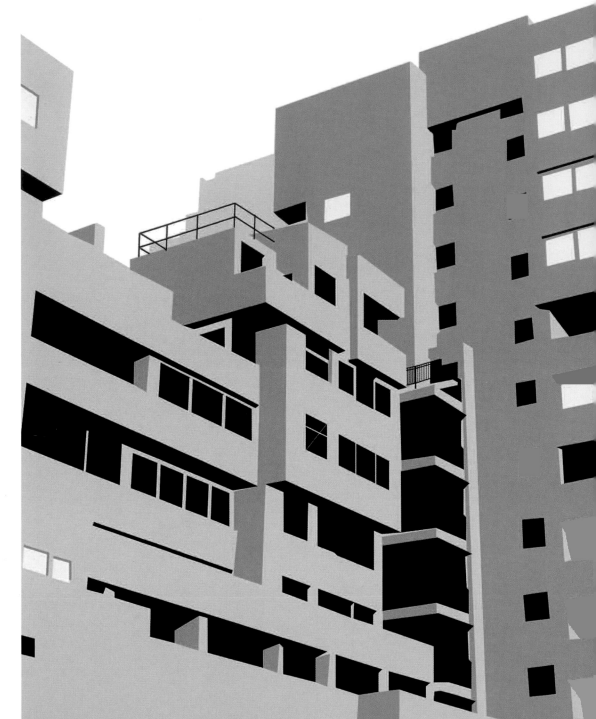

**Alex Sushon and
Miranda Iossifidis**
Pushbike Architecture
Treasure Hunt
HM Customs and Excise Building

Opposite:
P.A.T.H. typography in situ

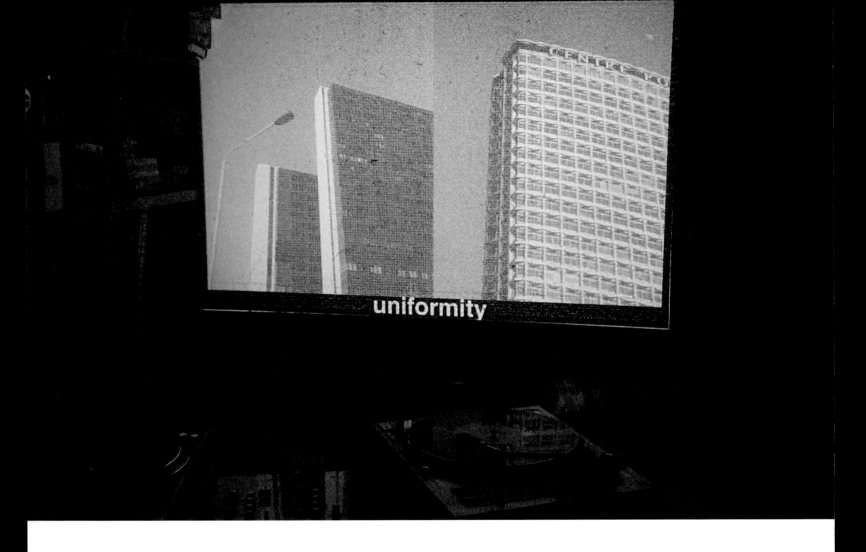

uniformity

Alex Sushon
part of Civil Perfection

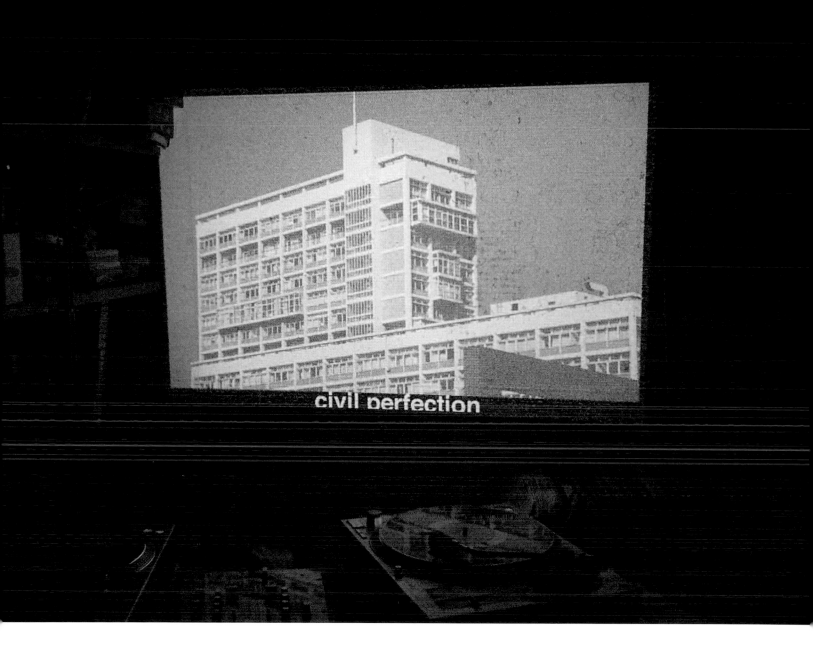

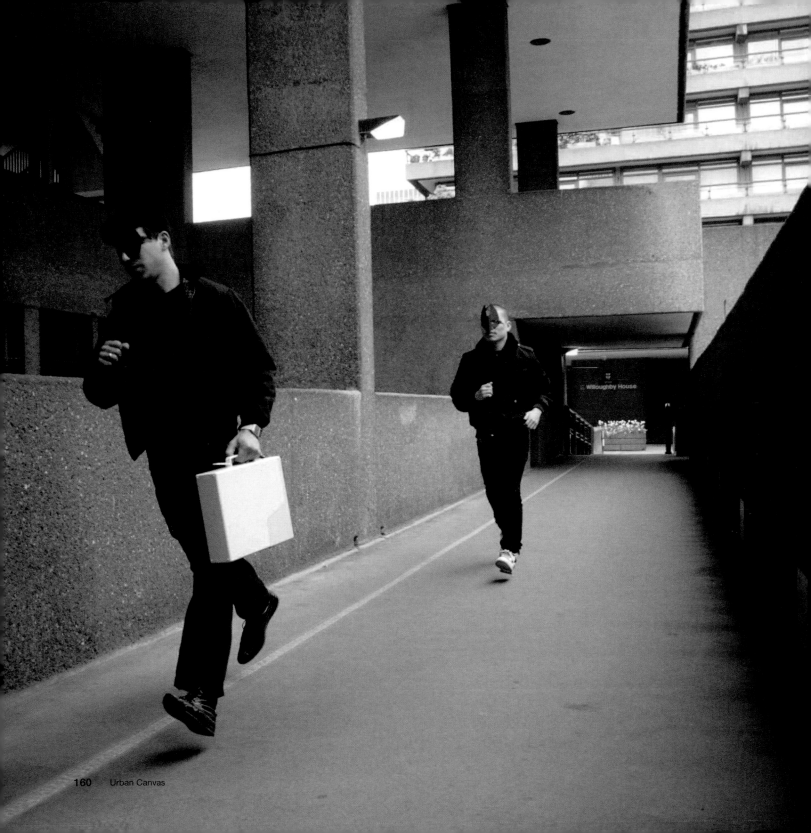

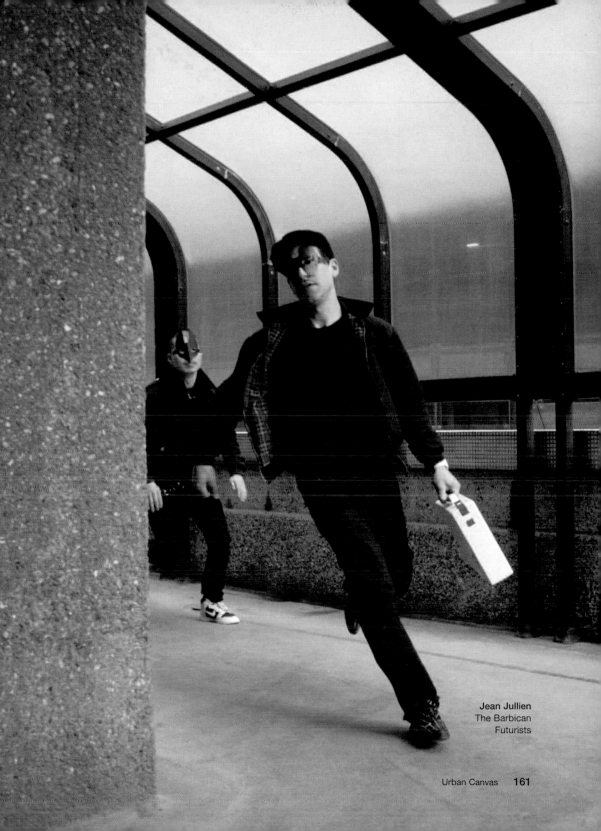

Jean Jullien
The Barbican
Futurists

Natasha Faith
Illustrating a garden

Leon Reid IV
Untitled, 2007

Leon Reid IV
Love is a Two-Way Street, 2007

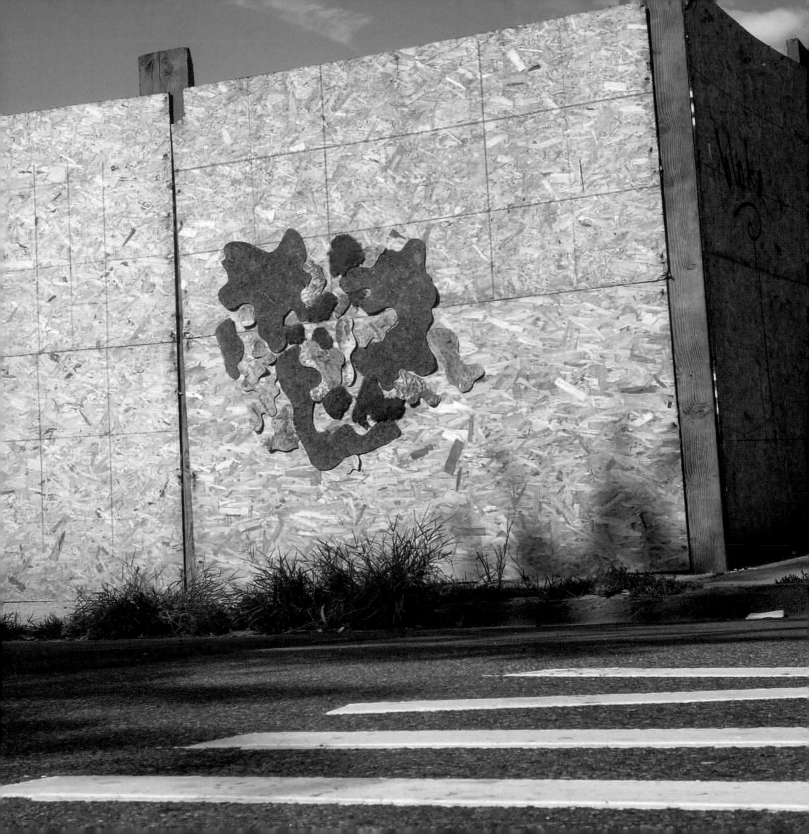

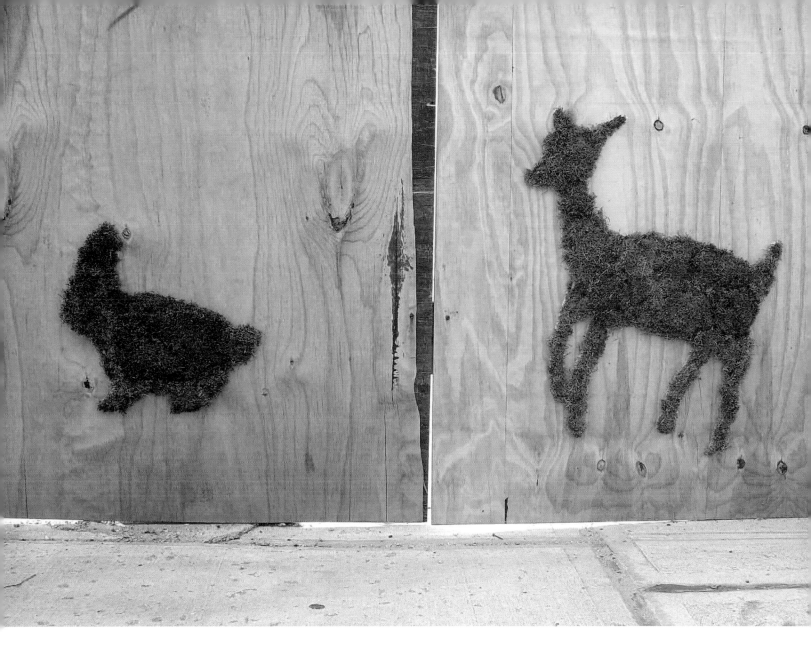

Edina Tokodi
Camouflage, installation NYC (opposite)
Nature, installation NYC (above)

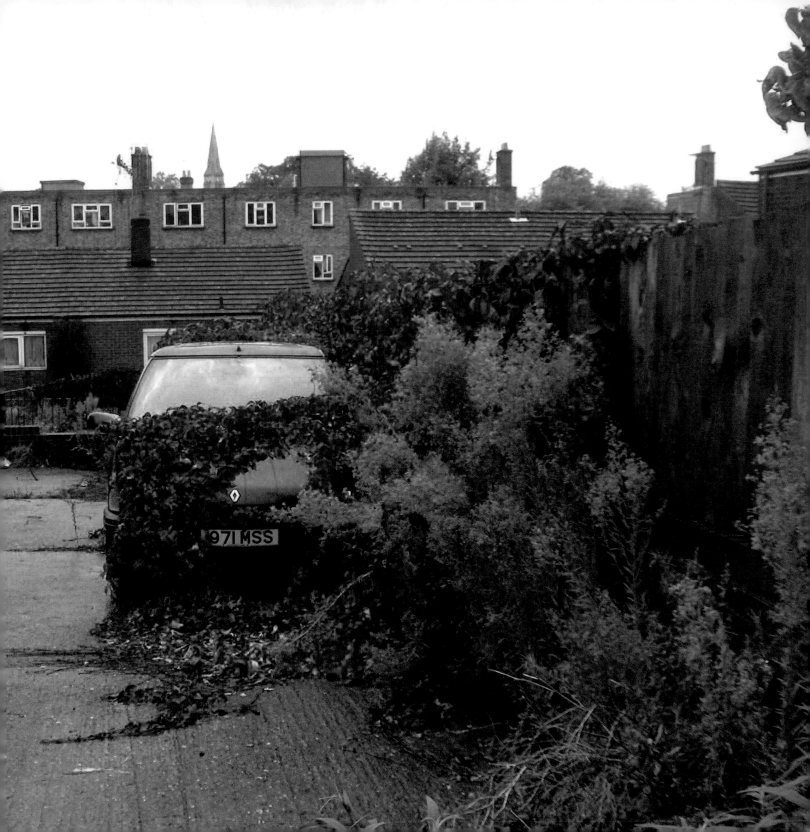

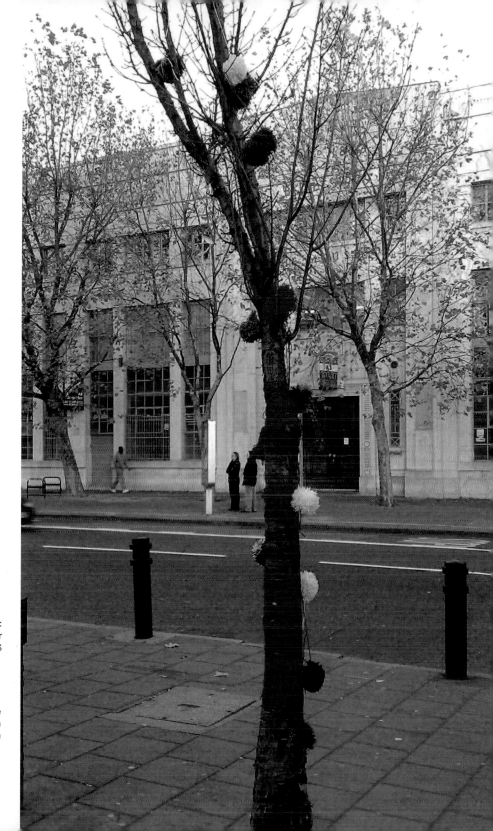

Opposite:
Eivind Søreng Molvaer
971 MSS

Knitted Tree
Artist unknown
Photography: Kevin Tallon

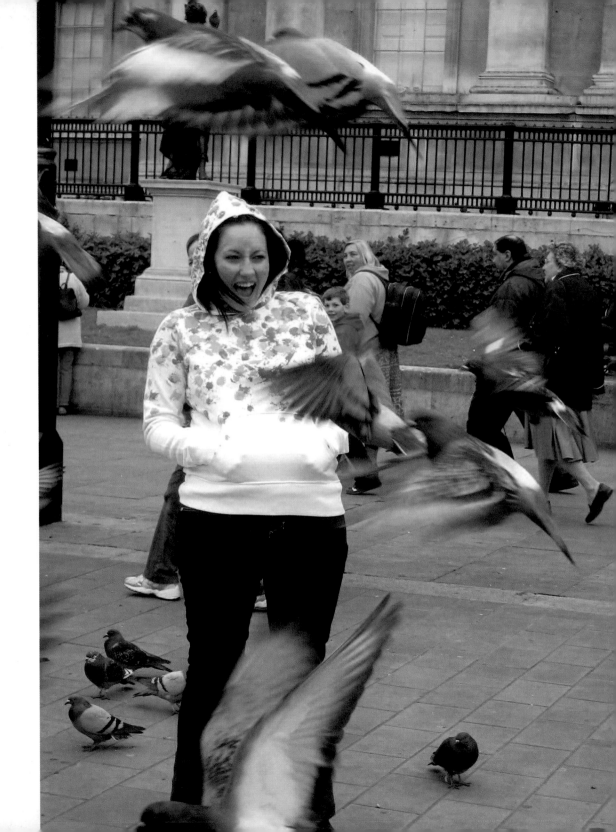

Alice Clarke
Alternative Camouflage:
Protecting you from the
perils of urban living

Michael Furlonger @ Elfdot
Isight

10.

Virtually Real

In our increasingly online lives – full of social networks, blogs and virtual worlds – we surf, consume and adopt online 'avatars'. We are spending more time than ever socializing, roleplaying, sharing files, emailing, 'YouTubeing', shopping and Facebooking. Our growing online life is influencing our everyday 'real life', from the obvious time dedicated to web activities to slower but more profound socio-cultural phenomena such as web addiction.

This brave new online world is also changing the face of our high street; whatever business can be done faster, cheaper and more conveniently on the web is emptying or even closing down shops on our streets. Creatives working with 'real' media are also influenced by anything and everything digital, literally transposing online visual language, such as Instant Messaging speech bubbles, third-person camera angles and polygonal objects, into the real world.

For some the desire for the latest technological upgrades, from the latest MP3 players, computers, mobile phones and games consoles, has reached a near-religious significance. Reacting against this digital idolatry, the 'Smash My…' movement is a more militant phenomenon in which teenage pranksters collect money from online benefactors to buy the latest hi-tech gadgets and then smash them to bits seconds after the purchase, posting the mayhem on dedicated web sites.

Performance artists influenced by online activities are also transposing online culture to the real world. Roleplay takes centre stage as artists and designers devise new forms of art and entertainment. For some, avatars and characteristics of the virtual and online worlds can easily be replicated by creating 'polygonal'-inspired costumes with head-mounted cameras to deliver a third-person perspective perfect for a stroll in a real park. Artists and designers are seen replicating retro graphics, playing out games using people instead of pixels.

Creating simple 3-D objects online has never been easier with the launch of free applications such as Google's SketchUp or Second Life's built-in 3-D modeller. The methodology and ease of use of 3-D modelling has encouraged designers to apply the same rules in the real world, rapidly producing simple and brightly coloured objects or shapes using card, emulating the visual language reminiscent of the early-eighties video arcades. Intrinsic features of objects found in 3-D environments, such as hollowness and non-functionality, are reproduced and replicated in reality.

The success of open-source software, with applications such as Firefox leading the web browser market, is evidence that values of accessibility and collaborative networks are the way forward. These values, developed entirely online, are starting to influence the real world. Businesses that are able to translate and deliver these values in the real world by collaborative development and openness will certainly be seen as innovators to follow in 2009 and 2010.

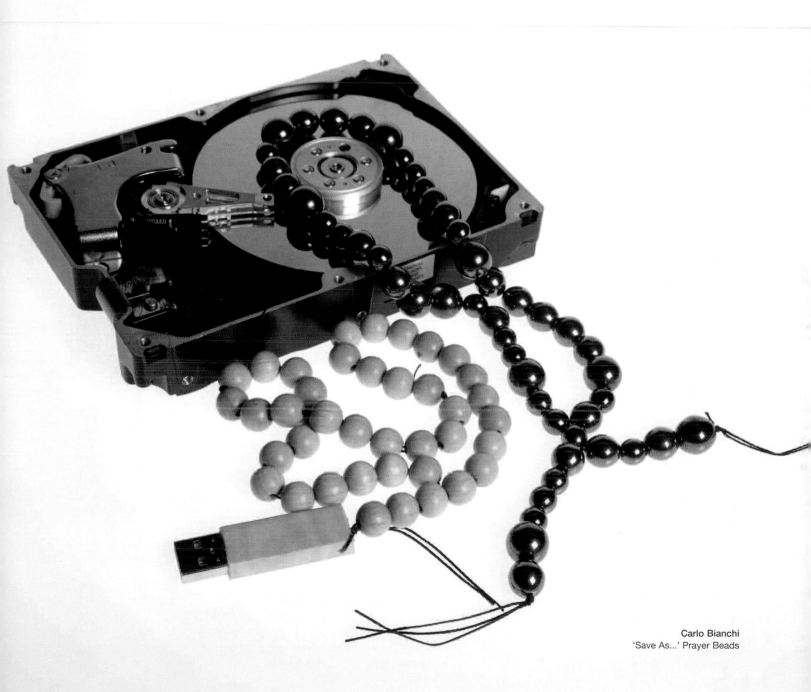

Carlo Bianchi
'Save As...' Prayer Beads

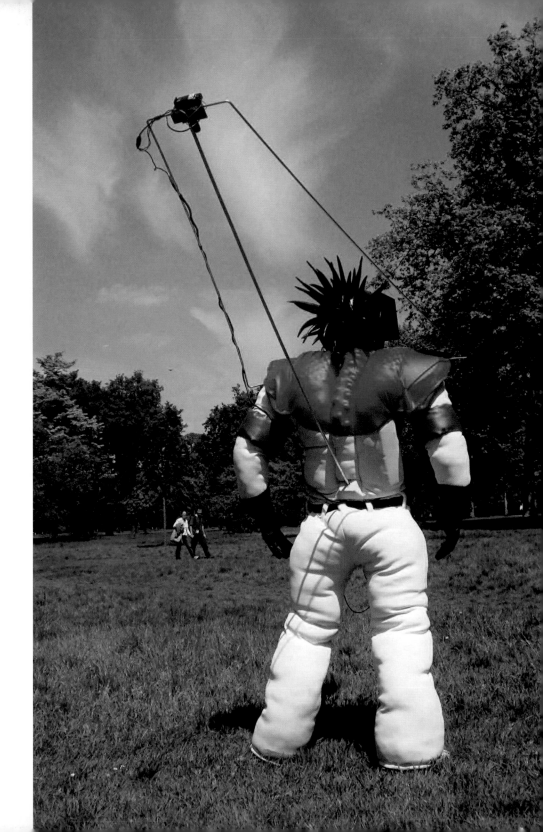

Marc Owens
Avatar Machine

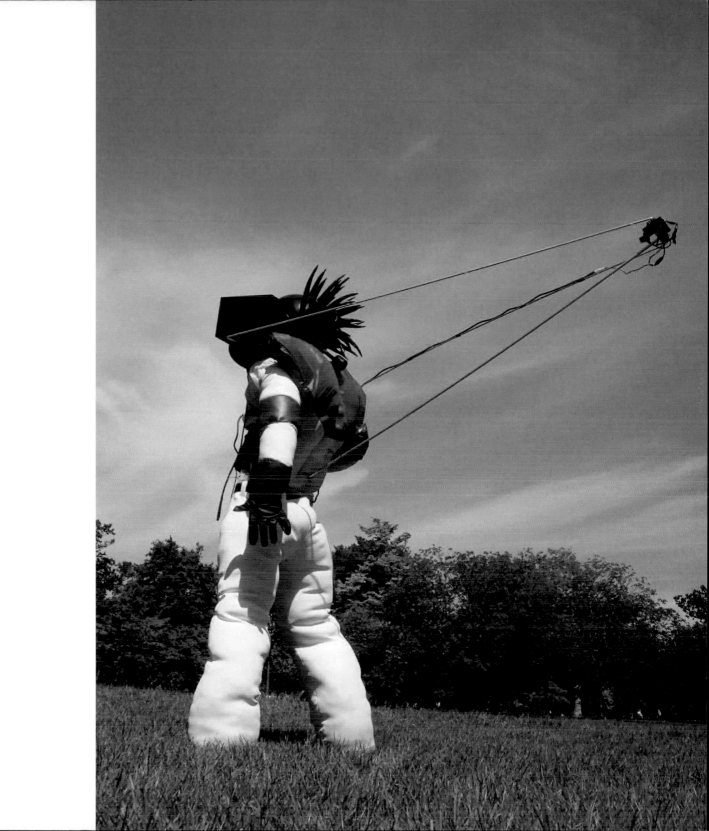

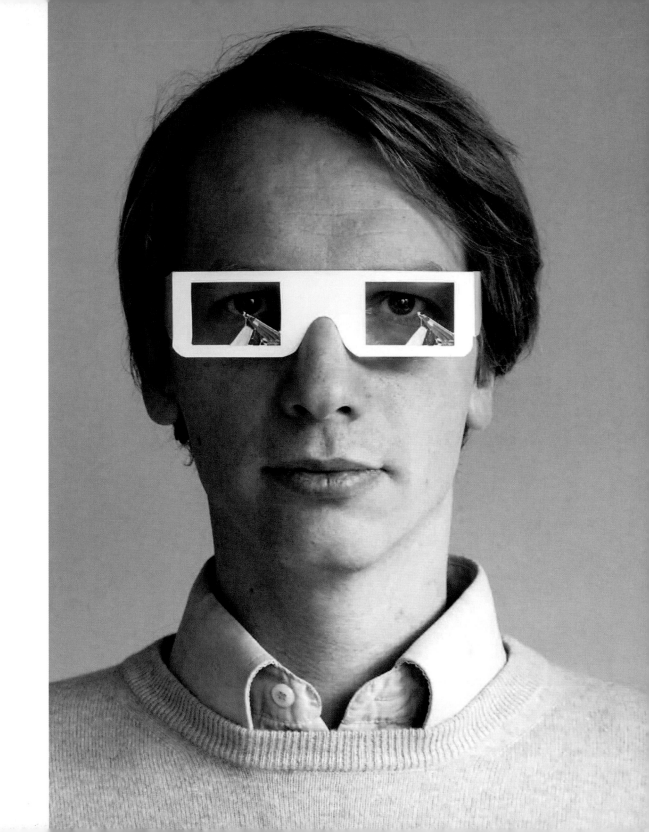

Aram Bartholl
First Person Shooter

Opposite:
Counter-Strike
Valve Software

176

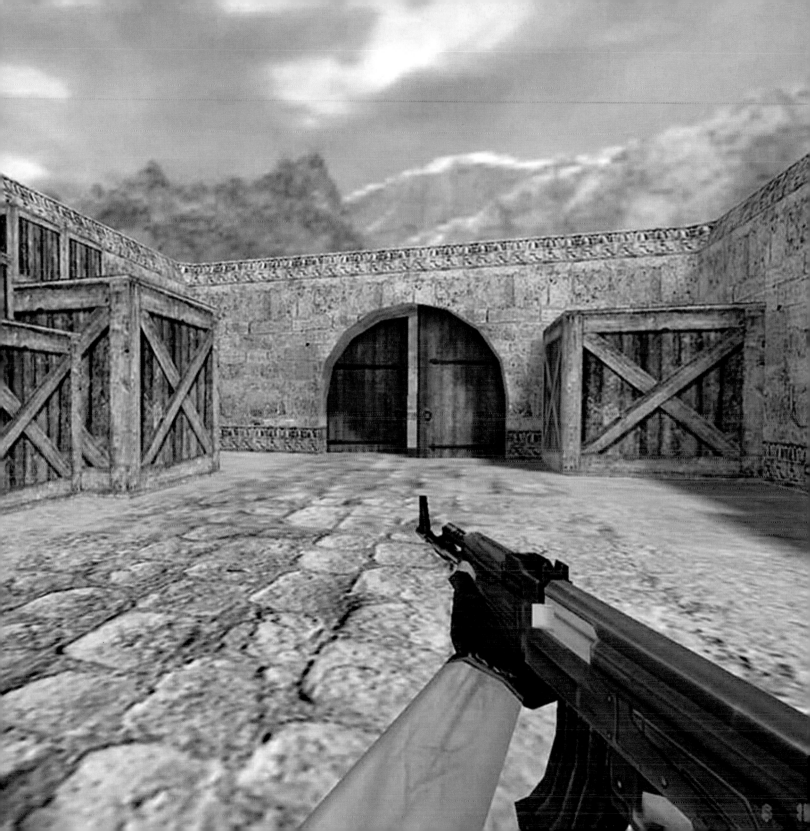

Guillaume Reymond
NOTsoNOISY
Space Invaders and Pole Position

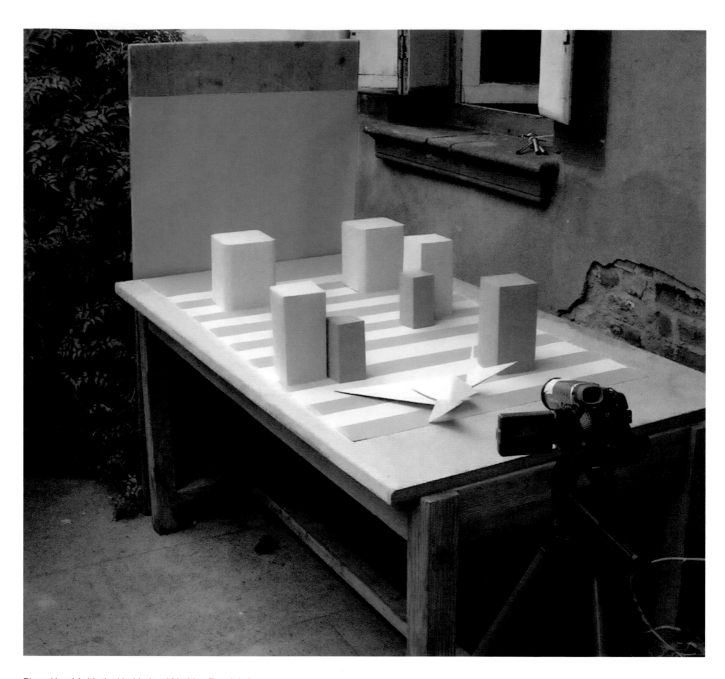

Pierre Vanni (with the kind help of Mathieu Fermigier)
Romantic Justice, 2007

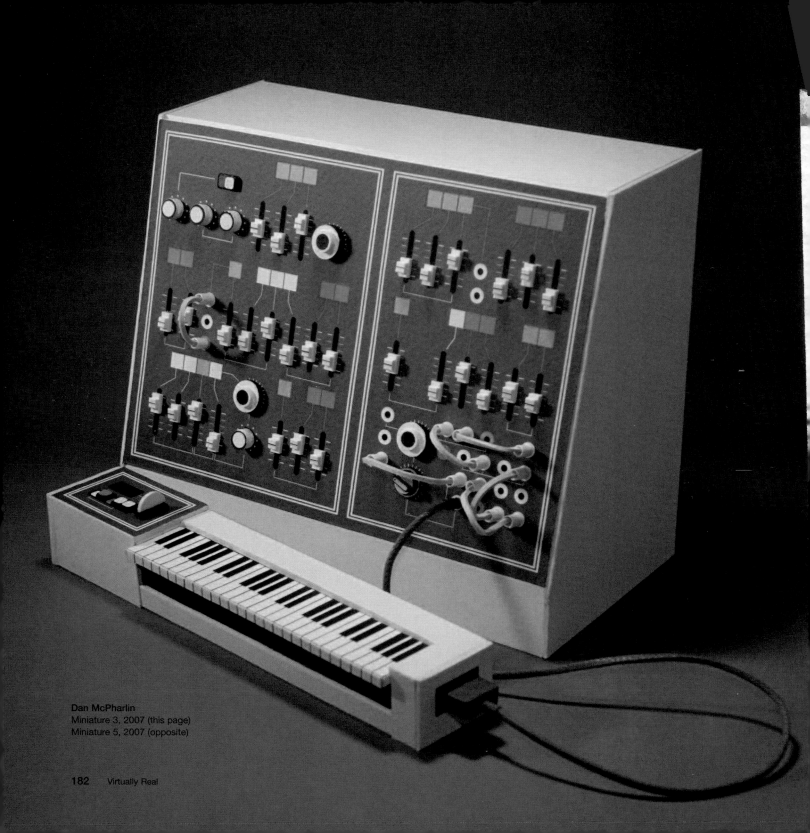

Dan McPharlin
Miniature 3, 2007 (this page)
Miniature 5, 2007 (opposite)

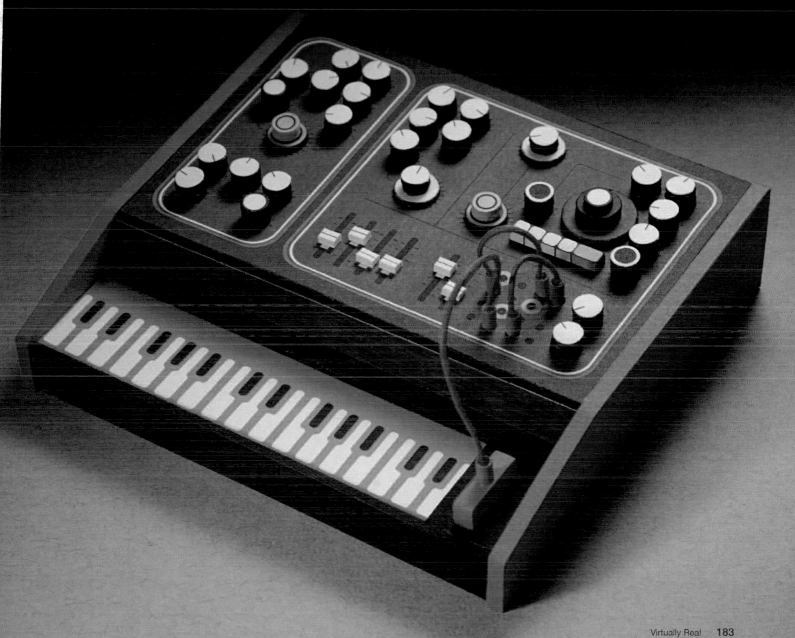

Aram Bartholl
Wow (right)
Chat (opposite)

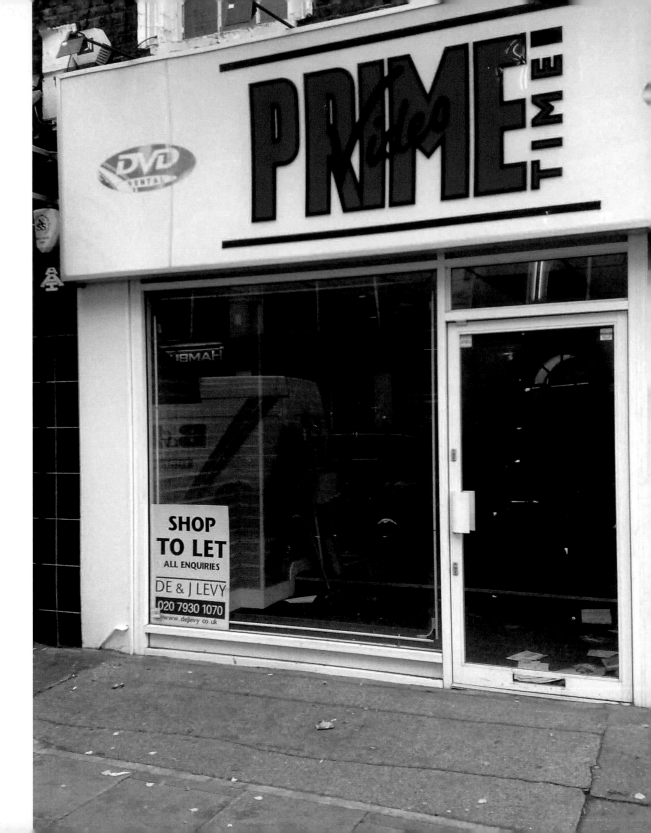

Kevin Tallon
Video Daze

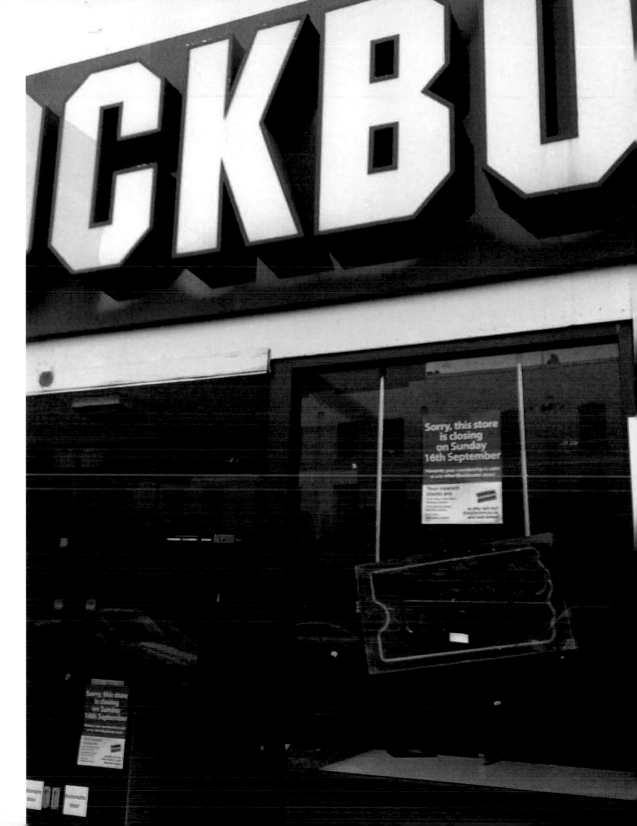

Kevin Tallon
Sorry This Store Is Closing

The internet was closed so I thought I'd come outside today.

Evan Ferstenfeld
The Internet was Closed...

Opposite:
smashsomestuff.com
Smash My iPhone

Smash My iPhone

When we get our hands on the Apple iPhone, we will destroy it in front of all the Apple fanboys. This is a social experiment for the entertainmentof the donors and visitor of our site.

Goal: $299 USD

0% 100%
Remaining: $0.00
Raised: $310.56

Make a Donation

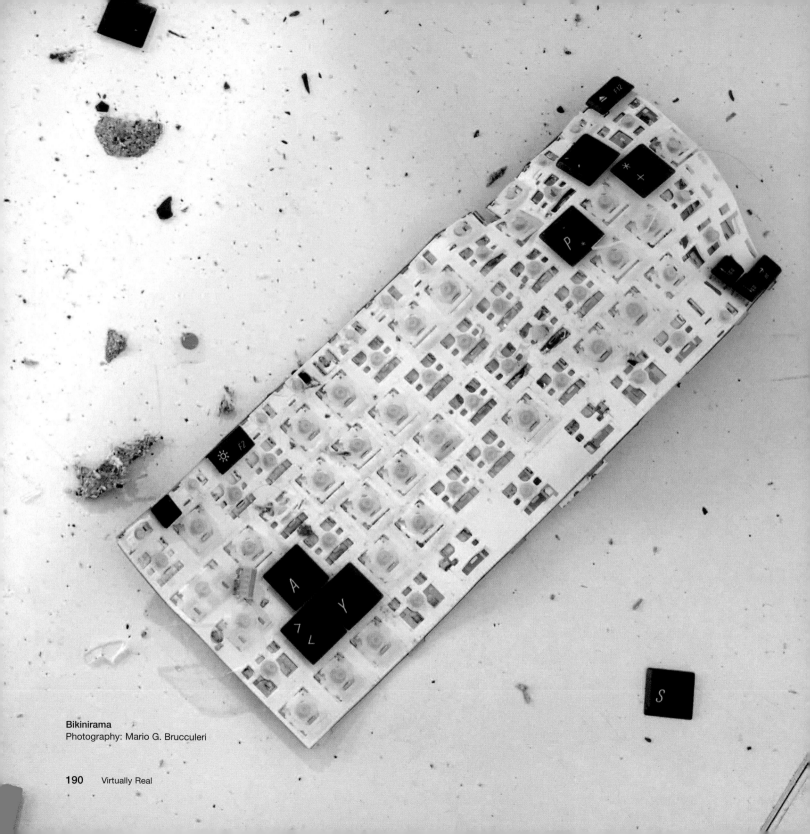

Bikinirama
Photography: Mario G. Brucculeri

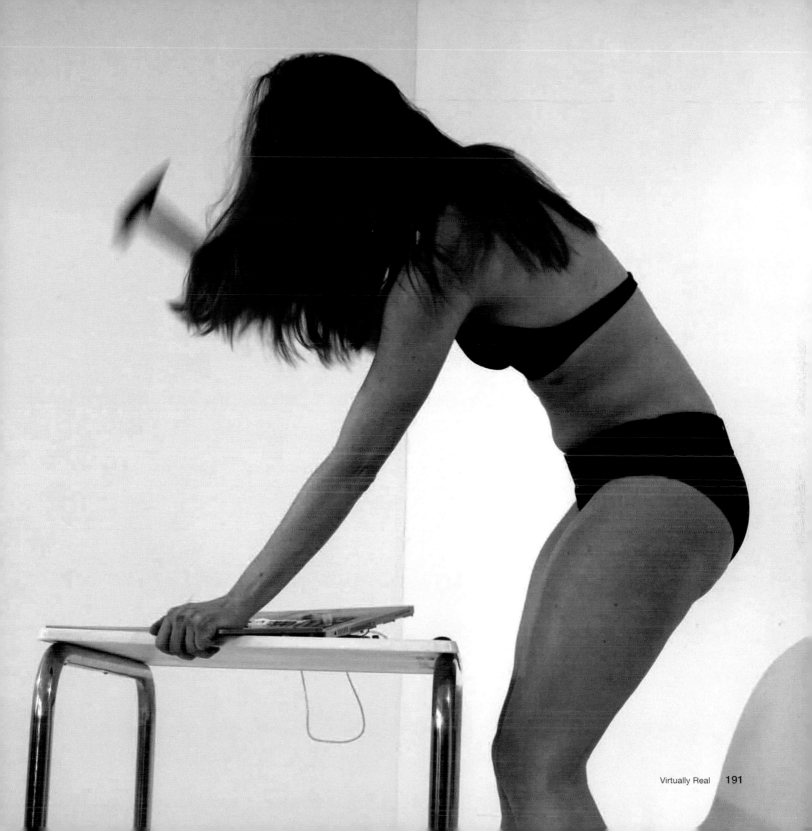

Bikinirama
Photography: Maria Monetti

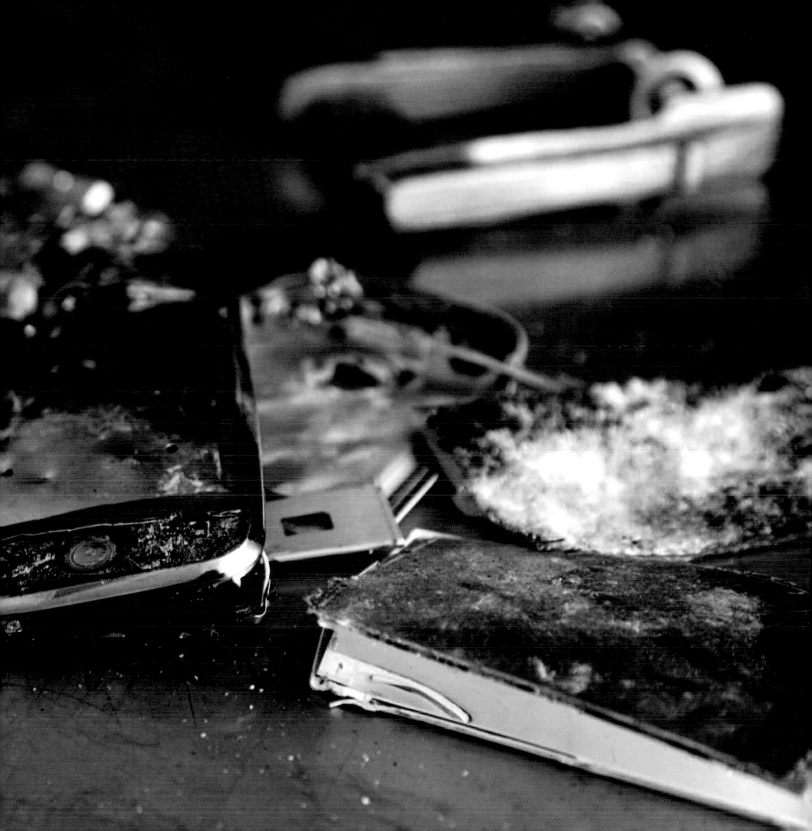

11.

Contacts

Martin Adolfsson
BA Graphic Design
Central Saint Martins
m@maad.se

Leonid Alexeev
BA Fashion Menswear
Central Saint Martins
www.leonidalexeev.com
info@leonidalexeev.com

Theodor Anastasato
BA Fashion Menswear
Central Saint Martins
anastasato@gmail.com

Tom Ballhatchet
MA Industrial Design
Central Saint Martins
tom@tomballhatchet.com

Sonia Barbate
BA Graphic Design
Camberwell College of Arts
soniabarbate@googlemail.com

Craig Barnes
BA Fine Art
Central Saint Martins
digger@madeonceonly.com

Max Barrett
BA Graphic Design
Central Saint Martins
www.maxbarrett.co.uk
max@maxbarrett.co.uk

Aram Bartholl
www.datenform.de
bartholl@datenform.de

Oscar Bauer
BA Graphic Design
Central Saint Martins
oscar@oscarandewan.co.uk
www.oscarandewan.co.uk

Katie Bean
BA Graphic Design
Camberwell College of Arts
katiecbean@gmail.com

Sophia Ben Yeder
MA Graphic Design
London College of Communication
www.benyedder.co.uk
sby@gmx.de

Rafal Benedek
MA Graphic Design
London College of Communication
rafbenedek@gmail.com

Carlo Bianchi
MAID
Central Saint Martins
carlobianchidesign@yahoo.it

Bikinirama
www.bikinirama.de
Kontakt@bikinirama.de

Paul Blease
MAID
Central Saint Martins
www.beingblease.com
pblease@googlemail.com

Kasia Bobula
BA Fashion Design Marketing
Central Saint Martins
kasia_bobula@hotmail.co.uk

Jamie Bowler
BA Fine Art
Central Saint Martins
www.jamiebowler.co.uk
jamiebowler@hotmail.co.uk

Nicholas Brown
BA Fine Art
Central Saint Martins
www.nicholasbrown.info
nick@kulturfabric.org

Tim Brown
Graphic Design
Duncan of Jordanstone College
of Art and Design
timfraserbrown@googlemail.com

Sofie Brunner
BA Textile Design
Central Saint Martins
brnner@yahoo.com

Matt Bucknall
BA Graphic Design
Central Saint Martins
www.mattbucknall.co.uk
matt@mattbucknall.co.uk

Coral Churchill
BA Fine Art
Central Saint Martins
www.coralchurchill.com
coral@coralchurchill.com

Matthew J Clark
BA Fine Art
Central Saint Martins
www.matthewjclark.co.uk
matthew.j.clark@hotmail.com

Alice Clarke
BA Graphic Design
Central Saint Martins
www.alice-clarke.co.uk
alice_francesca@hotmail.com

Rose Cobb
MA in Furniture
Buckinghamshire Chilterns University
College
www.designbyrose.co.uk
mail@designbyrose.co.uk

Sarah Cooper
BA Fine Art
Central Saint Martins
www.sarahkcooper.com
sarah@sarahkcooper.com

Reuben Cope
BA Fine Art
Central Saint Martins
reubencope@hotmail.com

Elena Corchero
MA Future Textile
Central Saint Martins
www.lostvalues.com
elena@lostvalues.com

Michael Costello
BA Fine Art
Central Saint Martins
mr_m_costello@hotmail.com

Joss Debae
BA Product Design
Central Saint Martins
www.jossdebae.com
joss@kith-kin.co.uk

Melanie Eddy
MA Design
Central Saint Martins
www.kith-kin.co.uk
mne_eddy@yahoo.co.uk

Maria Eisl
BA Art & Design
Central Saint Martins
www.mariaeisl.com
m@mariaeisl.com

Julie Elgar
BA Fine Art
Central Saint Martins
julie-elgar@hotmail.com

Andy Ellis
andyfgldn@gmail.com

Tom Estes
BA Fine Art
Central Saint Martins
tom estes8@hotmail.com

Natasha Faith
BA Graphic Design
Camberwell College of Arts
www.natashafaith.co.uk
natasha.faith1@gmail.com

Lucy Fergus
Ma Textile Futures
Central Saint Martins
lucy_a_fergus@hotmail.co.uk

Daniel Fernandez
BA Product Design
Central Saint Martins
danielfernandez.design@googlemail.com

Evan Ferstenfeld
frickinawesome@gmail.com

Letty Fox
BA Graphic Design
Camberwell College of Arts
www.lettyfox.com
design@lettyfox.com

Hayley Friel
BA Jewellery
Central Saint Martins
www.oheffie.co.uk
haylee@oheffie.co.uk

Masayoshi Fujikawa
BA Photography
Camberwell College of Arts
masayoshifujikawa@googlemail.com

Michael Furlonger
BA Fashion Menswear
Central Saint Martins
www.michaelfurlonger.com
furlongermichael@yahoo.co.uk

Alia Gargum
BA Fashion Illustration
London College of Fashion
www.aliagargum.com
aliagargum@gmail.com

Rachel Garrard
BA Fashion Design
Central Saint Martins
www.rachelgarrard.com
rachelgarrard@hotmail.com

Caroline Gates
BA Graphic Design
Camberwell College of Arts
caroline.er.gates@gmail.com

Lozan Ghafoor
BA Fine Art
Central Saint Martins
lozan_ghafoor@hotmail.co.uk

Emma Gibson
BA Fashion Illustration
London College of Fashion
www.egibson.co.uk
gibson.emma@gmail.com

Luke Goldsmith
BA Graphic Design
Central Saint Martins
lukegoldsmith84@gmail.com

Melanie Graf
BA Product Design
Central Saint Martins
www.mgproducts.co.uk
melg70@hotmail.com

Thibaud Herem
BA Graphic Design
Central Saint Martins
thibaud.herem@googlemail.com

Li Hon Lam
BA Interactive Design
London College of Communication
www.soundsbutter.com
ask@soundsbutter.com

Sophie Hwang
BA Graphic Design
Central Saint Martins
www.blassfisch.com
sophie@blassfisch.com

Jack Isenberg
BA Fashion Design Womenswear
Central Saint Martins
tomach21@yahoo.co.uk

Ditawatt Issarra
BA Product Design
Central Saint Martins
issara.d.esign@googlemail.com

Anneke Jacobs
Master of Applied Arts
Sandberg Institute, Amsterdam
wwww.annekejakobs.nl
info@annekejacobs.nl

Harriet Jordan-Wrench
BA Fine Art
Central Saint Martins
harriet_jordan@hotmail.com

Jean Jullien
BA Graphic Design
Central Saint Martins
www.jeanjullien.com
jean.jullien@gmail.com

Olga Kazakova
BA Fashion Design
Central Saint Martins

Stephen Kim
Master of Fine Arts, Design
Cranbrook Academy of Art
www.sixminute.com
steve@sixminute.com

James King
BA Product Design
Central Saint Martins
james@jameshuwking.com

Marie Kristiansen
BA Fine Art
Central Saint Martins
juliemarie.kristiansen@gmail.com

Sakis Kyratzis
BA Graphic Design
Central Saint Martins
www.actual-size.net
sakis_ky@yahoo.co.uk

Tai-Jung Lee
MA Industrial Design
Central Saint Martins
jocelinelee@hotmail.com

Matt Lippiatt
BA Fine Art
Central Saint Martins
www.mattlippiatt.co.uk
mattlippiatt@hotmail.com

Zhen Yuan Liu
MAID
Central Saint Martins
my_wonderful_days@hotmail.com

Craig Manley
BA Graphic Design
Central Saint Martins
www.craigmanley.co.uk
mail@craigmanley.co.uk

Felicity Marshall
BA Fashion Illustration
London College of Fashion
factory_girl@hotmail.com

Christopher May
BA Fine Art
Central Saint Martins
chris@christophermay.co.uk

Dan McPharlin
Visual Arts
University of South Australia
danmcpharlin@primus.com.au

Harunori Mochizuki
BA Fine Art
Chelsea College of Art and Design
www.harumochi.com
harumochi@hotmail.co.uk

Eivind Søreng Molvaer
BA Graphic Design
Central Saint Martins
www.eivindmolvaer.com
eivind@molvaer.com

Naty Moskovich
Industrial Design
Bezalel Academy of Art and Design,
Jerusalem
naty.mosko@gmail.com

Neda Niaraki
MA Textile Futures
Central Saint Martins
niarakineda@hotmail.com

Fabian Nyblom
BA Product Design
Central Saint Martins
fabbenyblom@hotmail.com

Arianna Osti
BA Graphic Design
Camberwell College of Arts
ianna84@yahoo.it

Marc Owens
MA Design Products
Royal College of Art
www.marcowens.co.uk
mo@marcowens.co.uk

Emma Puntis
BA Painting
Chelsea College of Art and Design
emmapuntis@hotmail.co.uk

Guillaume Raymond
press@notsonoisy.com

Henry Reeve
MAID
Central Saint Martins
www.henryreeve.com
henryjamesreeve@hotmail.co.uk

Leon Reid IV
MA Fine Art
Central Saint Martins
leon4th@gmail.com

Richard Reynolds
Geography (BA)
Oxford
richard@guerrillagardening.org

Ewan Robertson
BA Graphic Design
Central Saint Martins
www.oscarandewan.co.uk
ewan@oscarandewan.co.uk

Mario Rodrigues
BA Graphic Design
Central Saint Martins
mariorodriguess@hotmail.com

Gerasimina Saratopoulos
BA Product Design
Central Saint Martins
www.gerasimina.com
mina@gerasimina.com

Alli Sharma
BA Fine Art
Central Saint Martins
www.allisharma.com
alli.sharma@blueyonder.co.uk

Smash Some Stuff
www.smashsomestuff.com

Heather Smith
MA Textile Futures
Central Saint Martins
www.heathersmithcollection.com
contact@heathersmithcollection.com

Seetal Solanki
MA Textile Futures
Central Saint Martins
www.seetalsolanki.com
seetal@seetalsolanki.com

Bong Kyu Song
www.sdesignunit.com
sdesignunit@hotmail.com

Robert Stadler
Design
Istituto Europeo di Design, Milano
www.robertstadler.net
info@robertstadler.net

Alex Sushon
BA Graphic Design
Camberwell College of Arts
www.sushon.org
bok.bok.bok.bok.bok@gmail.com

Richard Sweeney
Three Dimensional Design
Manchester Met
www.richardsweeney.co.uk
mail@richardsweeney.co.uk

Kevin Tallon
BA Fashion Menswear
Central Saint Martins
Kevin@designlaboratory.co.uk

Edina Todoki

Graphic and Printmaking Department

Academy of Fine Art, Budapest

www.mosstika.com

edina.tokodi@gmail.com

Ian Tze Tsao Guilbault

BA Interactive Design

London College of Communication

www.soundsbutter.com

ask@soundsbutter.com

Tamsin Van Essen

BA Ceramic Design

Central Saint Martins

tamsin@vanessendesign.com

Ninette van Kamp

MA Textile Futures

Central Saint Martins

ninettevankamp@yahoo.co.uk

Pierre Vanni

Université de Toulouse

pvanni@hotmail.fr

Edward Vince

BA Product Design

Central Saint Martins

teddickvince@hotmail.com

VisuallYod

BA Ceramics

Central Saint Martins

info@visuallyod.co.uk

Isabelle Webster

BA Fine Art

Central Saint Martins

isabelle_webster@hotmail.com

David Wilson

BA Product Design

Central Saint Martins

davidasherwilson@googlemail.com

12.

A Special Thank You

It took me the best part of seven years to get from an original idea to a fully fledged book. During that time I met and worked with the most interesting and inspiring people ever, thank you all:

Brent Richard, Yann Mathias, Tim Hoar, Dani Salvadori, Yann Menard, Lisa Martin, Joss Debae, Camille Bouyez Forge, Vicki Loomes, Catherine Nippe, Brett Both AKA Brett Maverick, Georgina Roberts, Ellie Mathieson, Maria Eisl, Tanja Poralla, Vesna Pavlovic, George Walker, Alexandra Eggert, Binia Tallon, Lotta Veromaa, Mariana Bertrand, Carry Godsiff, Alenka Banik, Neus Rodriguez, Ellis Ruddick and all the forgotten ones...

13.

About Saints

University of the
Arts London
Central
Saint Martins

Central Saint Martins

Central Saint Martins' global reputation for creativity has influenced the worlds of art, design and performance for many years. We encourage innovation in our students and staff, creating a vital culture of discovery that promotes the highest standards and attracts students from all over the world. This vitality lives on in the distinguished alumni who have taken our ethos into the world, challenging fixed ideas and influencing all our lives in important ways. Our students and staff continue to be defined by their ambition and talent, their willingness to challenge and negotiate, and their passion and potential.

www.csm.arts.ac.uk

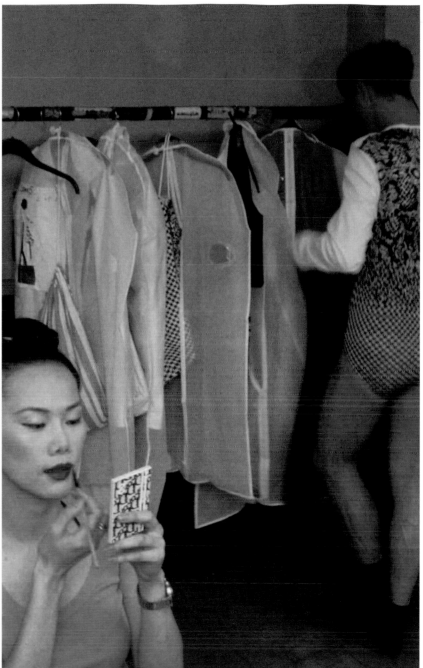

Saints – New Blood:Raw Trends

Discover today, and before anyone else, how the future Peter Blakes, John Gallianos and Stella McCartneys are envisioning the world of tomorrow.

Grown within Central Saint Martins Design Laboratory, Saints New Blood:Raw Trends helps understand and decipher emerging design and socio-cultural trends still being shaped by what we believe are the most creative, international and influential group of 20-something early adopters. We are constantly fascinated by the work and personalities that come out of Central Saint Martins and are sure you will be inspired too.

saintstrend.wordpress.com